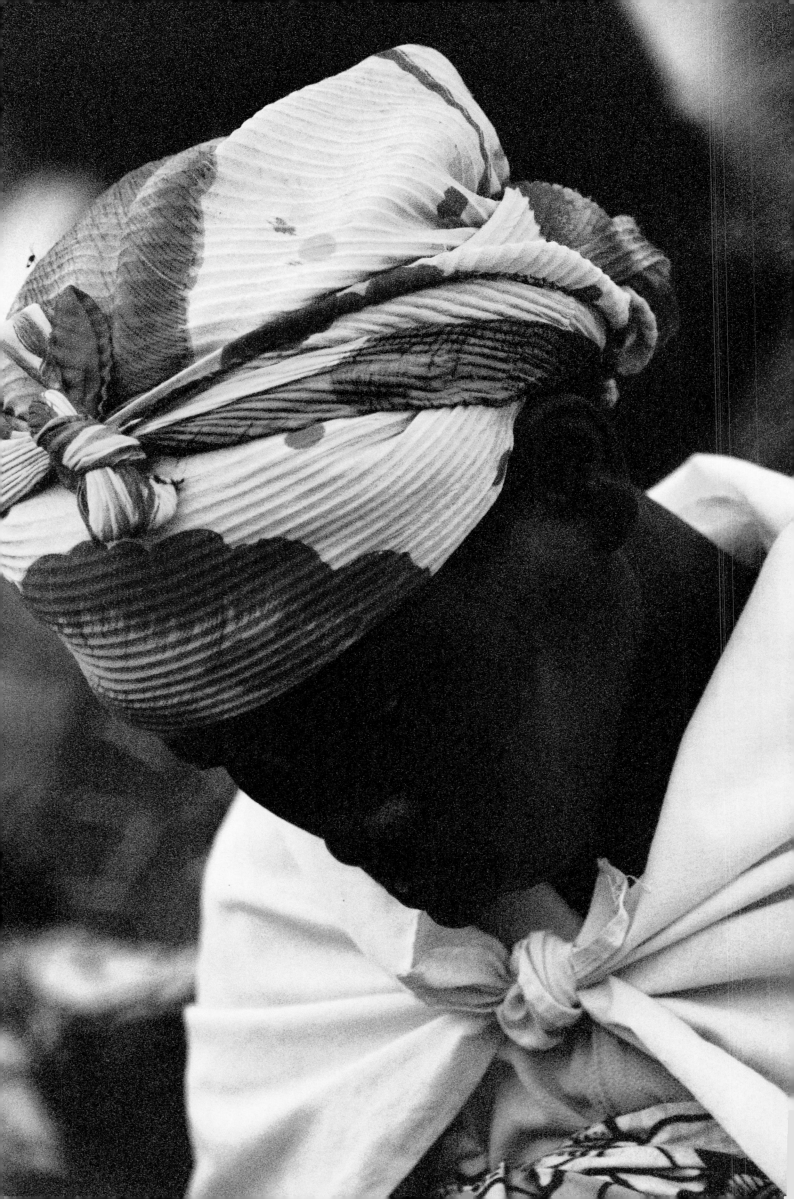

BETH O'DONNELL

ANGELS IN AFRICA

PROFILES OF SEVEN EXTRAORDINARY WOMEN

TEXT BY KIMBERLEY SEVCIK

THE VENDOME PRESS

To my sisters Kathleen Barry Ingram, the late Patricia Barry Turriff, and Julie Barry Carden

It all started in Africa, in Kenya. I had always dreamed of visiting Africa, and I fell in love with it the moment I arrived. I fell for the people, the land, the animals, and the light. To be in Africa is to know the place where man was born.

While in Nairobi on my way to safari, I could not help but notice the vast shanty towns, tin roofs stretching out as far as the eye could see, the slums of Nairobi. I was curious how a society at this level of poverty lived day to day. How was it possible that these people could carry on in such abject poverty?

Later, in 1999, I was in Africa with a friend who had first suggested the idea of writing a book on amazing African women. I saw the book as a way to express my passion for photography and my growing love for Africa and its extraordinary people. I was excited by the possibility of sharing the continent's native colors and breathtaking light with readers who might never have visited Africa.

The project began in Kenya, when my friend and I spent several days with Professor Wangari Maathai, the environmental activist who would win the Nobel Peace Prize for the environment in 2004—the first woman from Africa to be so honored. We hiked with her into the Karura Forest where she was protesting plans by the Kenyan govern-ment to build homes and a golf course on unspoiled tracts of the only remaining forest on the outskirts of Nairobi. She suggested that the book focus on grassroots women who were doing important work in their communities but lacked the opportunities that she had had. She introduced us to Esther Mwaura Muiru, director of GROOTS Kenya (Grassroots Organization Operating Together in Sisterhood). After she had made several more introductions for us, we entered, with some trepidation, the slum called Kibera in the middle of Nairobi and inhabited by more than a million people. A posh golf club borders the slum, offering a stark contrast to the incredible poverty. Kibera, the Nubian word for forest, is but one of many slums in Nairobi and it is probably the largest in Africa. Sixty percent of the residents of Nairobi, capital of Kenya, live in these slums. I knew immediately that Professor Maathai was right. The story that I wanted to tell would be best told through the eyes of the brave, strong women who, against all odds, feed, clothe, educate their children, give of their time and energy to those less fortunate then themselves, and give voice to those who need to be heard. These women are mothers, parents, teachers, and businesswomen. Sometimes they earn only pennies a day selling their beautifully displayed vegetables, but they always keep trying just the same. I know that God has worked through me, using my camera to capture and interpret what I have seen. I hope that I can convey, in this book, what I have felt.

In 2005, writer Kim Sevcik joined the project and she wrote the seven amazing stories of seven courageous women who hail from seven different sub-Saharan countries. Although they represent different cultures and customs, the women share the same grassroots objective of working hard to better their communities. They are all leaders, mentors, and heroes, and they exemplify a vast cross section of African women.

Ann Wanjiru of Kenya, a mother of three, has lost many family members and friends to HIV/AIDS. She gives of her time by feeding, cleaning, and lending a loving ear to those suffering from this devastating disease.

Edina Yahana's love for her native Tanzania and its lush rain-forested mountain ranges led her at the age of sixteen to help plant trees and educate villagers about the need for conservation. She has helped to plant more than a million trees and to save forests from decimation, thereby ensuring that the rain forests of the Eastern Arc of Africa remain intact for generations to come.

Celina Cossa of Mozambique lived through the devastating civil war in the 1970s and 1980s. At the age of twenty-five she confronted the hunger crisis that threatened her country by joining an agricultural cooperative on the outskirts of Maputo, the capital city of Mozambique. She now heads a union of 250 collectives providing enough food to feed its six thousand members and more. Celina was awarded the Hunger Project's prestigious Africa Prize in 1998. She generously donated all of the monies from the prize back to the UGC, the General Union of Co-Operatives, to help the cooperative to expand.

Pascasie Mukamunigo comes from Rwanda and bears within her a heart of forgiveness. She knows that forgiving, without ever forgetting, is the only way for her country to move forward, after having suffered the atrocities of the April 1994 genocide. By bridging the divide between Hutus and Tutsis through basket weaving, she has helped to mend a broken country.

Prudence Mwandla of South Africa was gripped by a grief so powerful that the only way for her to heal was to give of herself by opening a shelter for AIDS orphans who had been abandoned, abused, and who were sick and hungry.

Aminata Dieyé has been a women's rights crusader in Senegal for two decades. She thought that women should and could earn the same wages as men, and so she has been helping to train and procure apprenticeships for young, unskilled women in metalworking, carpentering, and other jobs traditionally held by men.

Jacqueline Goita wanted desperately to help impoverished young girls coming every day from rural areas to Bamako, the capital city of Mali, looking for jobs as domestic workers. Many times these young women are underpaid and overworked. They are also vulnerable to physical and sexual abuse. Jacqueline helps these women by tutoring them in literacy and domestic skills so they are able to command higher wages. She also educates them about their rights and brings cases of rape and abuse to court.

Within a few years there will be more than twenty million children orphaned by AIDS. How can we ignore them? This is a question that I ask myself and you as readers of this book. We have so much to be grateful for. A cornucopia of wealth and knowledge, all the necessities of life. I trust that many of you want to help. And if there is one thing that I know, it is that one person can make a difference. Awareness is the key to change. I am hoping that the stories of these women will inspire you as they did me to help them in anyway that you can. No one on this earth should be living in such poverty. No child should go hungry. Let us embrace each other. Let us hold hands. Let us share our stories. Let us open our hearts. They need our support, these Angels in Africa with hearts of gold.

—BETH O'DONNELL
June 2006

INTRODUCTION We hear so much bad news about Africa in the West. We read about the inexplicable civil wars, the staggering AIDS rates, the poverty and famine and corruption and riots. Rarely do we hear about attempts to address these problems—and when we do, they generally focus on the efforts spearheaded by Western aid agencies who descend on these blighted countries like superheroes with baby formula and armored vehicles and antiretrovirals. Yet for every crisis burdening sub-Saharan Africa, there are also legions of Africans toiling away, intent on coming up with their own solutions. And while the presidents and the diplomats and the captains of industry in sub-Saharan Africa are primarily men—as they are in so many parts of the world—the people leading the grass-roots efforts to combat poverty and illiteracy and AIDS are overwhelmingly women.

Those women are the subject of this book: visionary women who, with few financial resources and limited education, have devoted themselves to improving life in their native countries. Armed with little more than the courage of their convictions, they are taking on sub-Saharan Africa's most critical problems. They are nursing neglected AIDS patients and taking in their children, healing rifts between mortal enemies, creating economic opportunities to lift their compatriots out of poverty, and protecting the poorest, most vulnerable girls in society from exploitation. Because they work close to the ground, and because they have a profound understanding of their own communities, they are often more effective and nimble than government or foreign aid agencies in implementing solutions to seemingly insurmountable problems.

Intent on drawing attention to the hopeful things going on in sub-Saharan Africa, we set out to produce a book that would celebrate seven women, each of whom was tackling a distinct social problem in her country. We looked for women who were working in relative obscurity, women who had risen to leadership without the benefit of political connections, family wealth, or Harvard educations. In short, ordinary women doing extraordinary things. We thought these criteria might limit our pool of candidates. We were wrong. Recommendations streamed in from all corners of the continent, and each woman was as impressive as the next. We heard about women who were fighting for access to AIDS medication, women who were teaching kids to mentor younger kids, women who were struggling to free children who had been abducted and forced to fight civil wars. Clearly, finding seven outstanding women would not be difficult. The challenge would be deciding which seven stood out above all others. In the end, we did not choose the seven women most worthy of recognition. We could not. We simply chose seven extraordinary African women, knowing that they represented dozens of equally extraordinary African women who have devoted themselves to fixing what much of the world perceives as unfixable.

While we have attempted to slice the book into neat chapters featuring seven women in seven countries crusading for change in seven areas of concern, we realize, of course, that none of these problems occur in isolation. Where there is war, there is poverty; where there is poverty, there is child labor; where there is child labor, there is illiteracy; where there is illiteracy, there is AIDS, and so on. They are interconnected, all of these things. In helping to solve one problem, these women are, directly and indirectly, helping to solve many.

As we traveled to each country to meet the women and observe their projects, we were struck by their ability to persist in the face of overwhelming obstacles. In Rwanda, Pascasie Mukamunigo was repeatedly shunned when she tried to resurrect a weaving cooperative to reunite Hutus and Tutsis after the genocide. In South Africa, Prudence Mwandla and the eighty orphans she was caring for almost found themselves on the street when the house she was renting was repossessed. In Mozambique, floods destroyed hundreds of acres of farmland and the brand-new chicken-breeding farm that Celina Cossa had launched in an attempt to fend off malnutrition and starvation. All of these women know what it is to feel the slide toward hopelessness. All of them have wondered from time to time whether it was healthy or prudent or sane, even, to press on. And yet, they have.

The seven women featured in this book are remarkable for their compassion, their courage, their intelligence, their resourcefulness, and their commitment. But what impressed us most is their refusal to accept the idea that change is impossible. We hope that they will inspire our readers as much as they have inspired us.

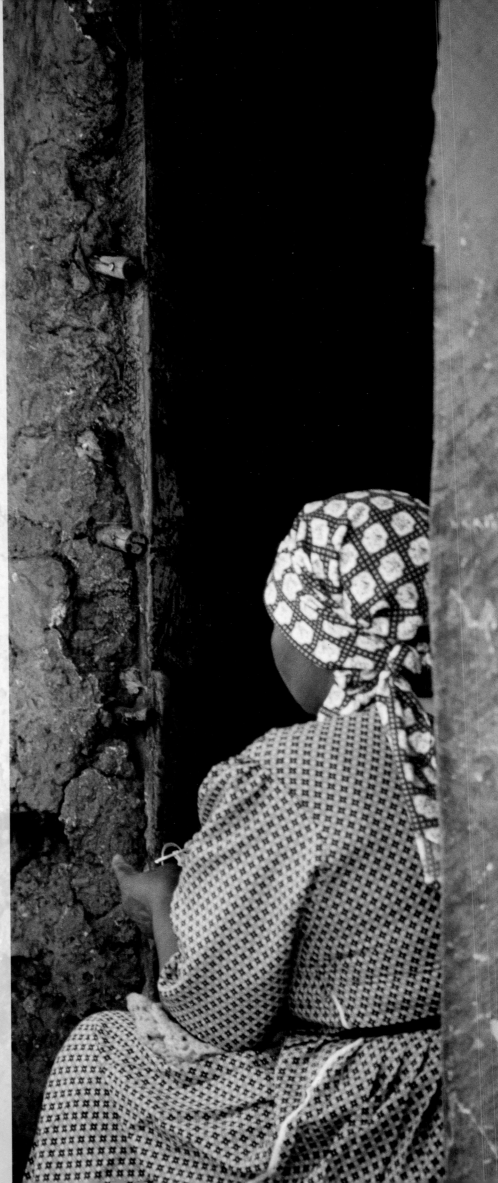

HISTORY OF REGION:

Kenya is a nation of rich geography, from the glacial ice of Mt. Kenya to arid desert land, from the tropical forest along the Indian Ocean coast to Lake Victoria, the second largest freshwater lake in the world.

The region was populated by a mixture of African tribal people prior to the arrival of Arab invaders in the first century AD. In 1498 the Portuguese became the first Europeans to explore the East African coast, with the German and British settling there over the next few hundred years. White settlers succeeded in making Kenya a British colony in 1920, and one year later the native Kikuyu created the first African political protest movement against this colonization. The movement gave rise to the Kenya African Union, and Jomo Kenyatta, known as the "Light of Kenya," was named its president in 1947.

Between 1952 and 1959 Mau Mau freedom fighters staged a violent campaign to end British rule in Kenya. Change came from this state of emergency, with Jomo Kenyatta leading Kenya to independence in 1963. As the president of the new republic, Kenyatta endeavored to unite all races and tribes with his call of *"Harambee,"* a rallying cry toward self-sufficiency.

CURRENT SITUATION:

The 34,707,817 people in Kenya today face the catastrophic results of years of droughts and the HIV/AIDS epidemic. With an unemployment rate of 40% as of 2001 and 50% of its inhabitants living below the poverty line in 2000, Kenya is a nation of economic struggle.

Following Jomo Kenyatta's death in 1978, Daniel Toroitich arap Moi came into power and remained there until 2002, when Mwai Kibaki of the multiethnic National Rainbow Coalition was peacefully elected into office. The aim of this current government is to eradicate the intense corruption of the past and encourage outside donor support.

AIDS
KENYA

ANN WANJIRU

When Elizabeth Nduku's husband died of AIDS seven years ago, her in-laws accused her of infecting him and kicked her out of their house. She moved to Nairobi from her village and rented a dimly lit room in a slum called Mathare. It is a tiny room, crowded with a few pieces of simple furniture: a crude wooden bench, a couple of stools, a box masquerading as a table, and a thin mattress lying across a slab of plywood. She has tried to beautify it as best she can, with crocheted doilies and embroidered handkerchiefs.

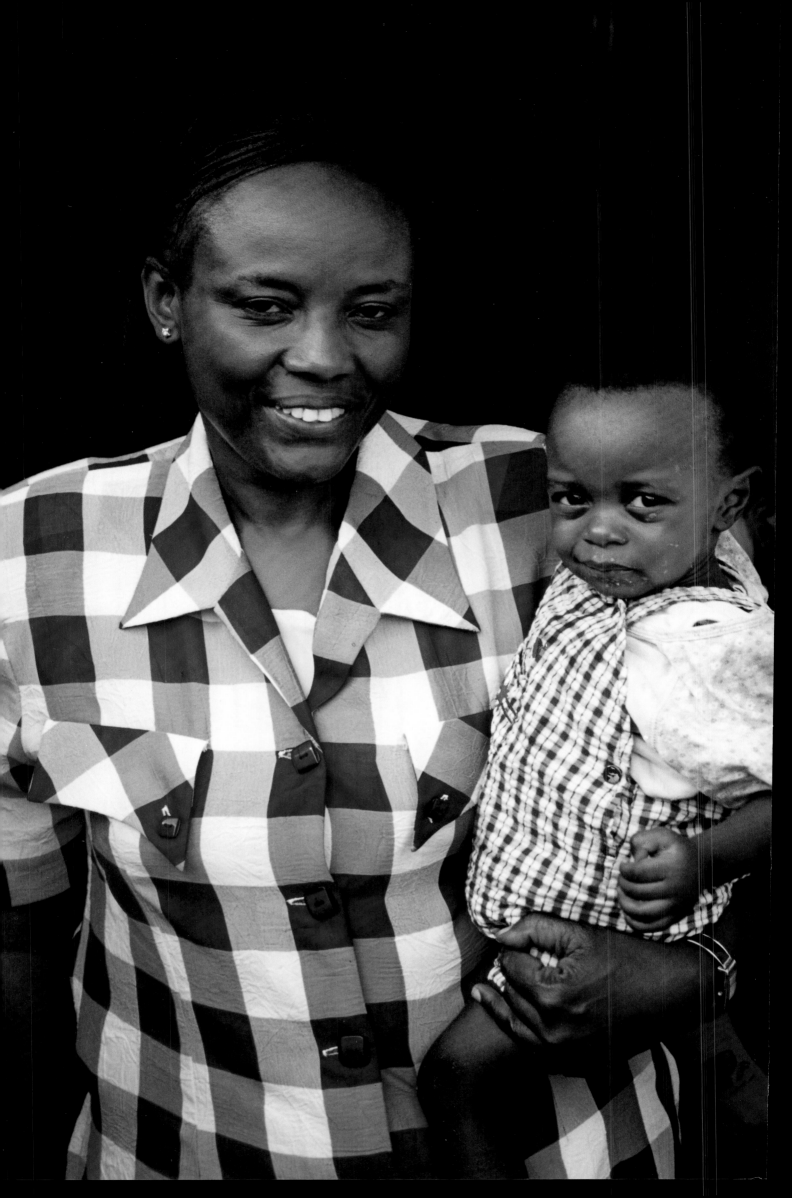

Elizabeth is thirty-eight years old, but she has the frail body of an adolescent girl. Occasionally, she will wake up feeling strong and pick up some work hand washing clothes for fifty shillings (seventy cents) a day. But most days, she is too tired and sick to do much of anything—her joints ache and her nerves tingle and her skin itches from the rashes that constantly plague her— so she sits in the room alone. Her family has shunned her. Her eight-year-old daughter is at school from early morning until late afternoon. Her neighbors, who live within a few feet of her front door, across an open sewer, pretend that she does not exist. They know that she has AIDS, and in the slums of Nairobi people living with HIV/AIDS are still treated like pariahs.

The only relief for her isolation are the visits she gets from Ann Wanjiru, a volunteer caregiver who began visiting Elizabeth two years ago. Ann is cochairperson of the home-based caregivers group for the Kenya chapter of an organization called GROOTS, which stands for Grassroots Organizations Operating Together in Sisterhood. Ann leads meetings and coordinates efforts to raise money to provide food or medicine in desperate situations, but the caregiver group works as a single, unified body— its members make decisions by consensus and resist giving or receiving individual credit for their work. Every day, twenty-five caregivers fan out among the ten "villages" in the slum of Mathare, caring for a total of 450 AIDS patients who either cannot afford hospital treatment or have been turned away for lack of space.

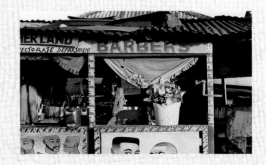

Mathare is one of the largest slums in Africa, and despite its poverty, it vibrates with life. Children run through the street with toys they have improvised from discarded items—wire and batteries and bits of brightly colored plastic. Goats rout around towering heaps of trash. Radios crackle from the lace-curtained windows of shops and houses. But beneath every corrugated tin roof, inside every butcher shop and tailor shop, is a person who has lost a child or aunt or husband to AIDS. More than one million people in Kenya are living with HIV, and one in five people in the slums of Nairobi are estimated to have the disease.

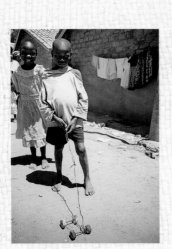

Myths about how AIDS is transmitted and its supposed cure still abound in Kenya, as they do in many African countries. One of the most prevalent and dangerous misconceptions circulating is that having sex with a virgin can cure HIV. In 2005, the biggest crime in the country was rape of minors. That, and traditions such as wife inheritance, whereby men in the Luo culture inherit their brother's wives when they die, is promoting the spread of HIV infection. If a woman's husband dies of AIDS, invariably she is also infected, and in marrying his brother, she passes it to both him and his first wife.

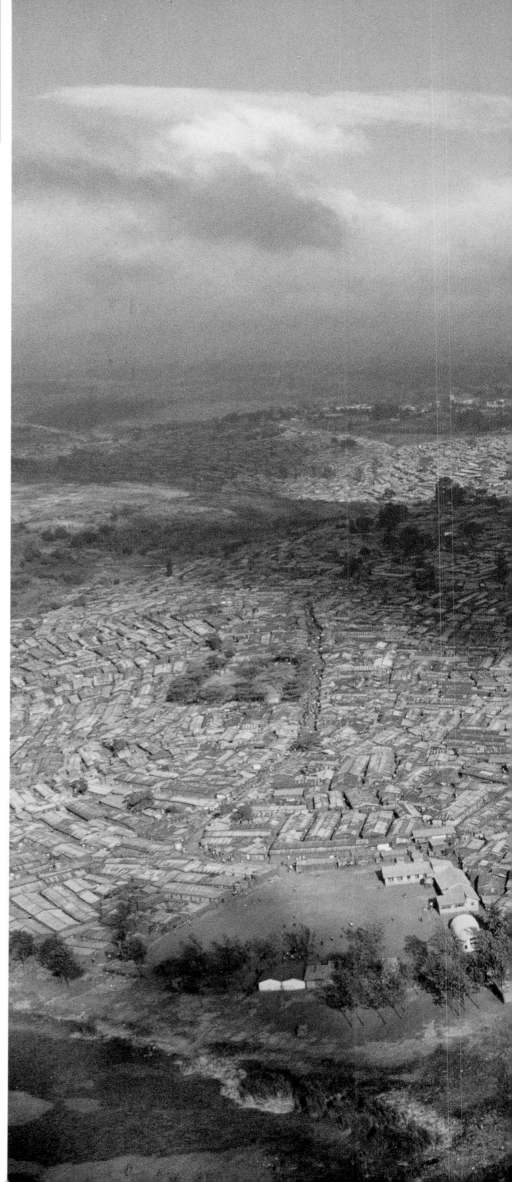

Aerial views of the Kibera slum,
Nairobi, Kenya.

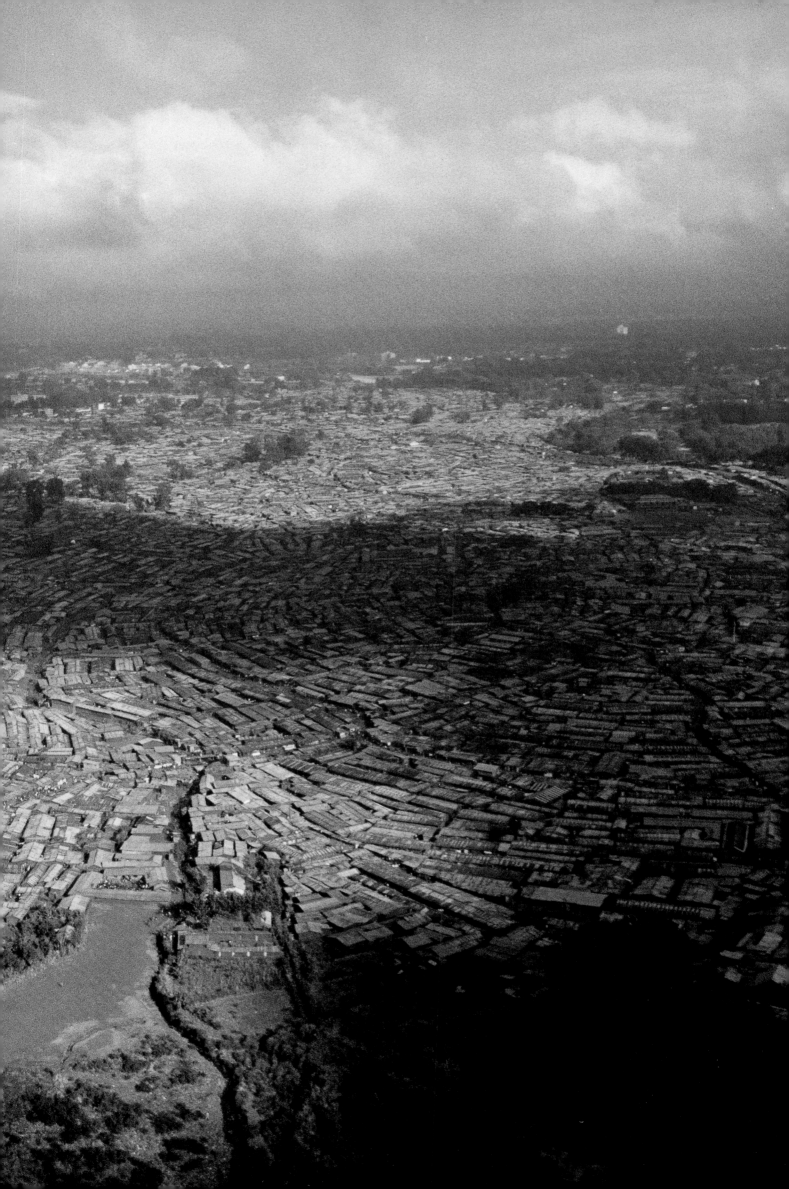

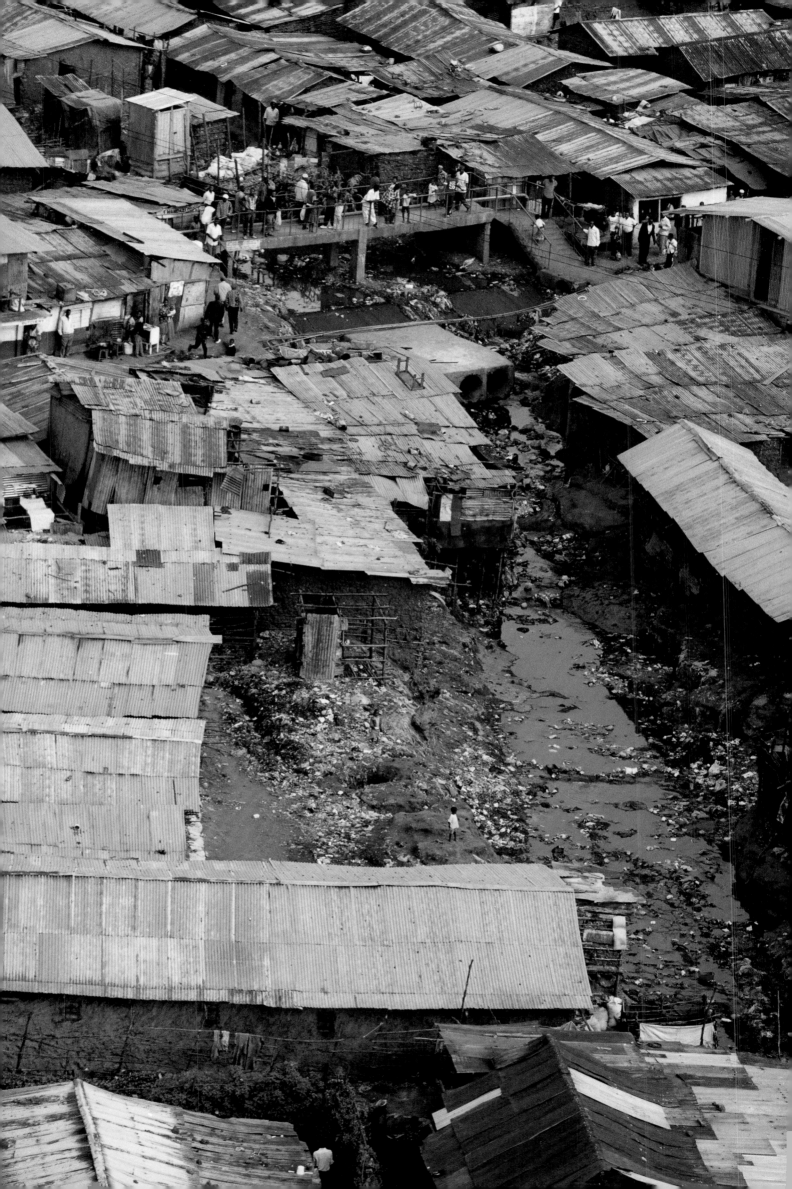

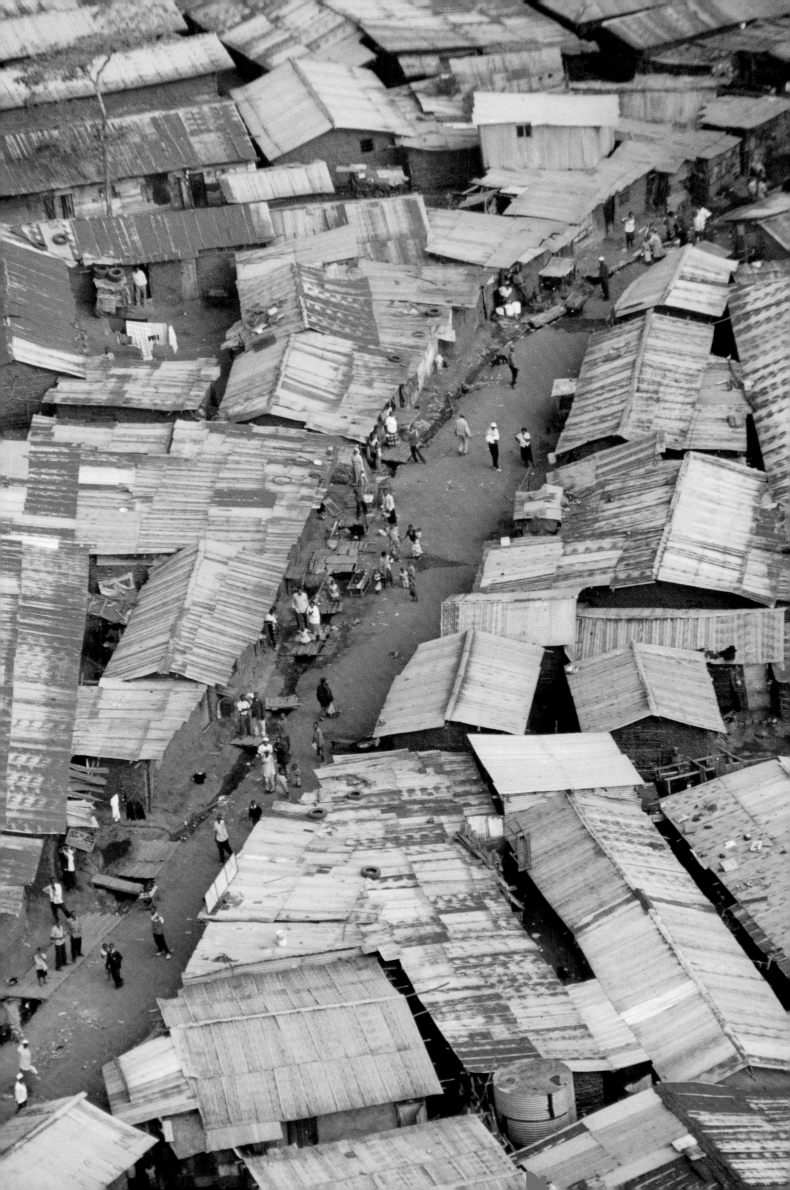

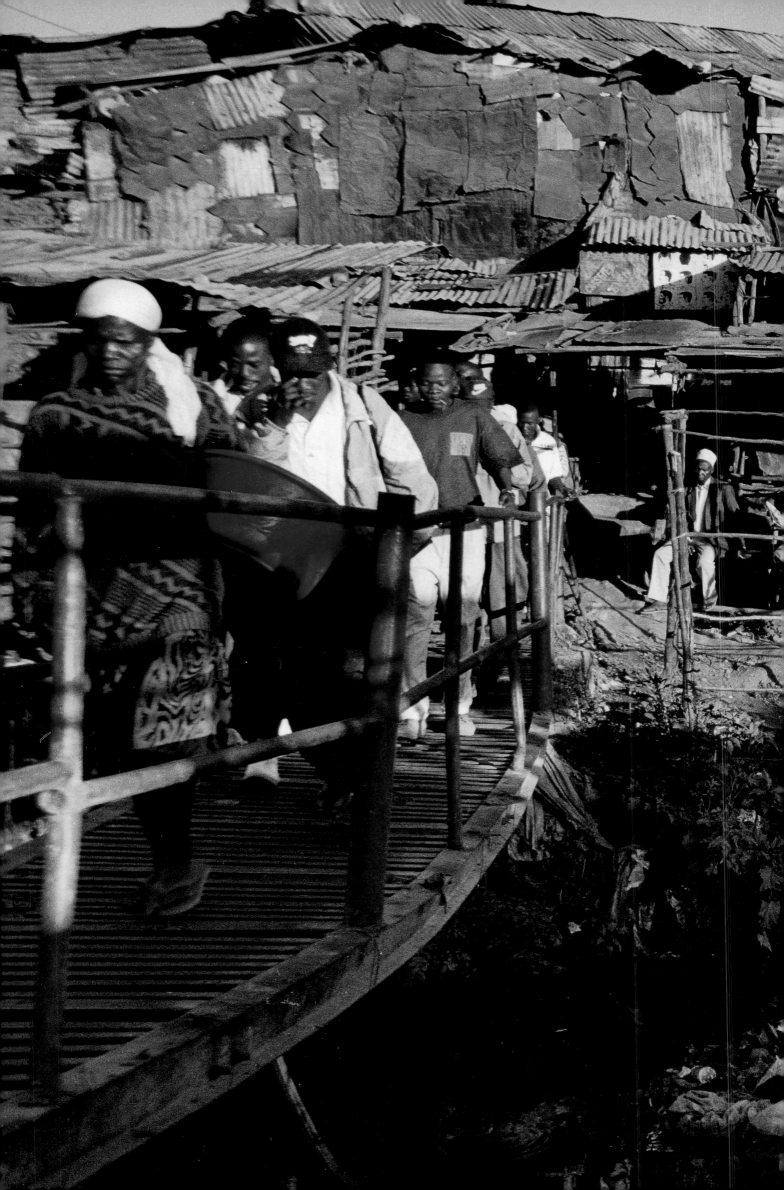

People associate **AIDS** with immorality
so they feel they must
banish these women
from their homes,
so it doesn't destroy
the family's reputation.

There are times when Elizabeth is too sick to get out of bed for days, times when her medication makes her so sick that she cannot keep down food, or when her stomach is so empty that she cannot keep down medication. But the most painful part of her disease is the isolation. "As Africans, the only thing we have are our social networks," says Esther Mwaura Muiru, the founder of the GROOTS Kenya chapter. "The idea of being cut off from our family and friends terrifies us. So people fear not just the illness itself—they fear the stigmatization, the way it robs you of human contact." The stigma for women is particularly bad. Because their status is lower than the status of men, women are routinely blamed for infecting their husbands. Many are cast out of their homes and villages, unfairly accused of being prostitutes. "People associate AIDS wth immorality," says Esther, "so they feel they must banish these women from their homes, so it doesn't destroy the family's reputation."

As head of the home-based caregiver program, Ann trains other volunteers how to take care of people living with HIV/AIDS while protecting themselves from infection. The group meets once a week in a concrete-floored room, its facade painted with a sign advertising Cozy Dishes. On the walls of the room are knitting samples of sweaters and patterns cut from paper bags. In 2005, one of the members began teaching teenage AIDS orphans how to knit, to help them earn a living as well as giving them a sense of purpose and accomplishment. Most of them have babies to support, as well as siblings, and they have been traumatized by the experience of watching their own parents die of AIDS.

Ann and her team of caregivers generally stop by the houses of their patients—whom they tactfully refer to as "friends"—two or three times a week, but if the person is bedridden, they visit every day. They might bathe the patient and change his or her sheets. They might clean her house or wash her clothes or bring her a tin of food, often purchased with money from their own pockets. The caregivers can scarcely afford it—they work as seamstresses or garbage collectors, and are barely scraping by themselves—but they know they are in a better position than the patients, who, like Elizabeth, are often too weak to work. Caregivers are often frustrated that they do not have the financial resources to help their patients the way they want to. At the caregivers weekly support group meeting, a woman named Jane tells of a dying patient who needed desperately to go to the hospital. Because she could not afford the cab fare, Jane had to stand by the side of the road with a bowl, begging, before she could transport her. A young male caregiver named Stephen introduces us to one of his patients, a twenty-year-old boy named Joseph who suffers from polio and AIDS. The effects of both diseases have rendered him unable to walk, so the only way that he can get fresh air is to squat on the banks of the open sewer that runs in front of his house. The caregivers association has discussed buying him a wheelchair, but that would diminish the funds they use to keep patients alive with food.

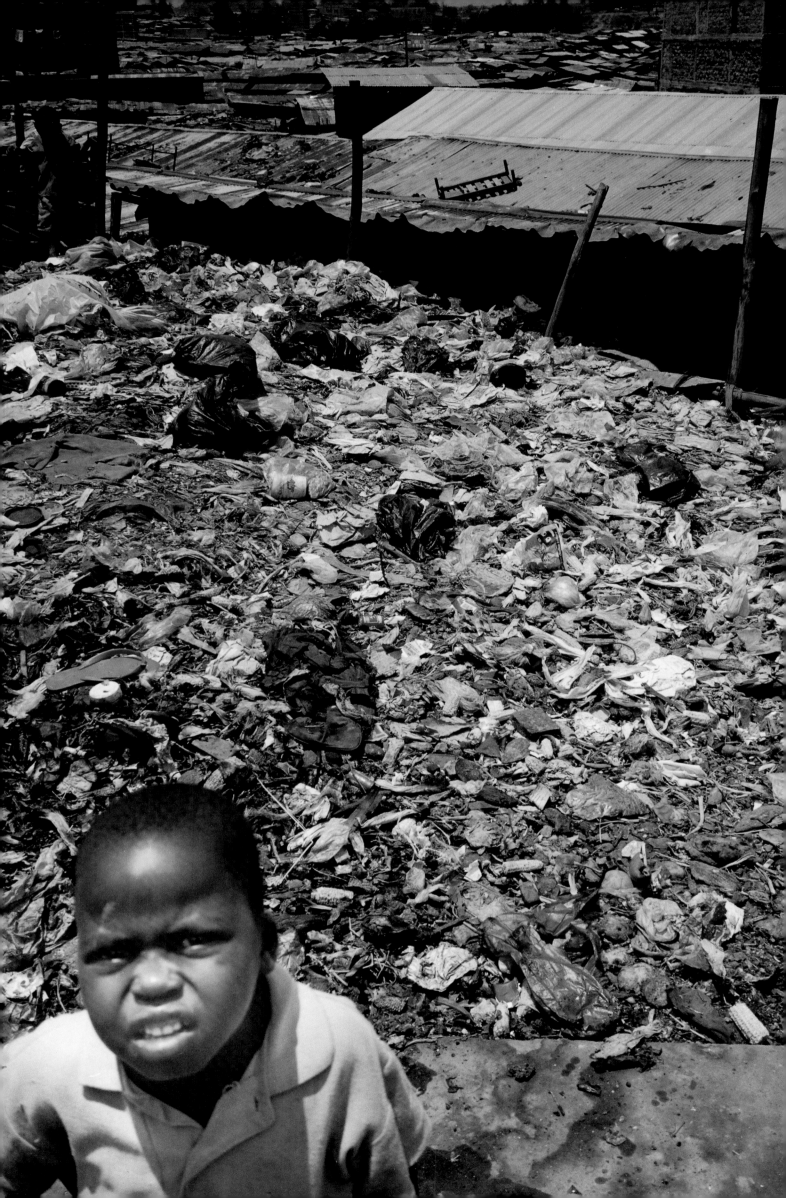

Nutritious food is a critical part of the regimen for people living with AIDS. Rose Omia, who cochairs the caregivers group with Ann, runs a feeding program in Mathare, which provides 250 sick people with a healthy hot meal. Every day, Rose, a rotund woman with a broad, shining face, cooks a washtub-sized pot of vegetable stew for AIDS patients and other infirm people in the slums. The stew is packed with nutrients: in it are beans, carrots, spinach, onions, tomatoes, and herbs. Around noon, clients begin to line up against a blue wall painted with letters of the alphabet, clutching empty plastic containers. When they reach the front of the line, Rose and her assistant give them a large scoop of rice and a ladle full of stew. This single meal is integral to maintaining an AIDS patient's health. In order for patients to be able to take the antiretroviral medication that helps keep them alive, they must have a full stomach to digest the medication, and they must have certain nutrients in their system to be able to absorb it.

If patients are unable to walk the half-mile or so from their homes to Rose's feeding center, caregivers will pick up the food for them. Food may be a physical necessity for people suffering from AIDS, but the comfort and company provided by their caregivers is just as essential. Rejected by those closest to them, people living with AIDS often need human connection more than anything. "These people need someone to talk to about their anxiety and their grief," says Ann. "They don't want to burden their children with this talk, or to make them any more afraid than they already are. Listening is the biggest gift we can give them." But listening can be a challenge. Many patients are angry and embittered, and they take out their agitation on their caregivers. "So often, the people I visit are losing hope," says Ann. " They don't feel there is any meaning in their life."

PRECEDING
In the Mathare slum garbage is rarely hauled away. Instead, it is piled into towering heaps behind the houses.
OPPOSITE
Joseph, age twenty, is sick with both HIV/AIDS and polio.
THIS PAGE
Three of the hundreds of AIDS patients visited each week by GROOTS caregivers.

So often, the people I visit are losing hope. They don't feel there is any meaning in their life.

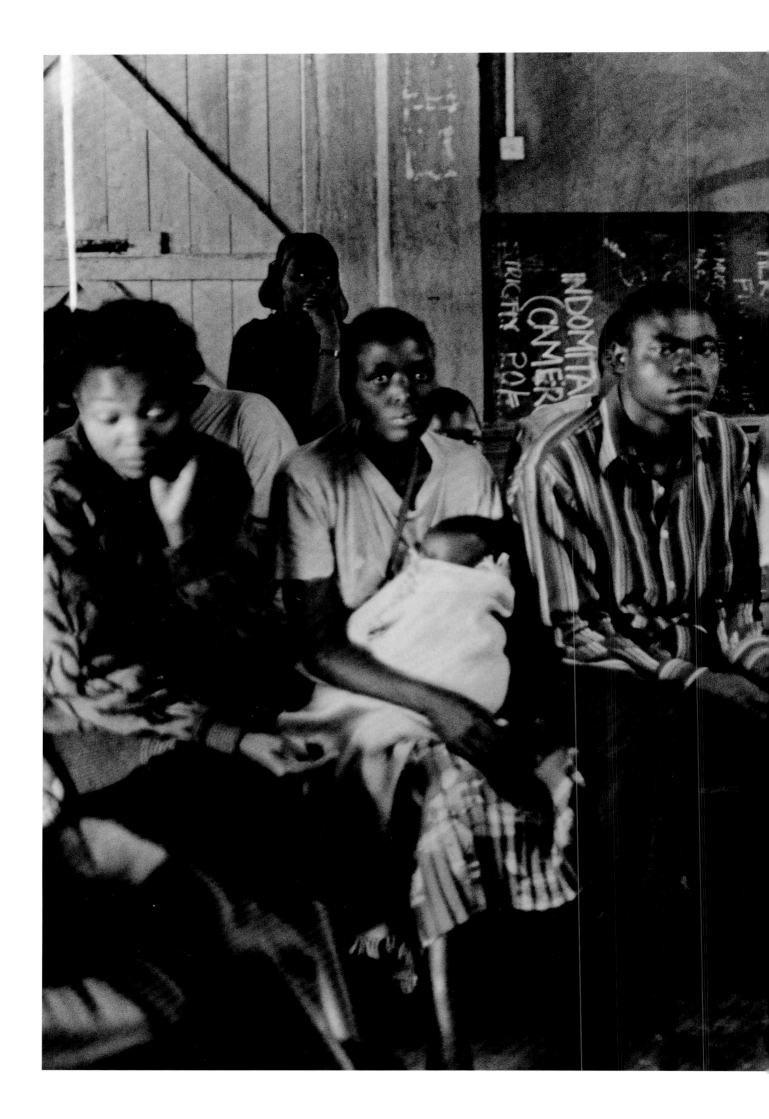

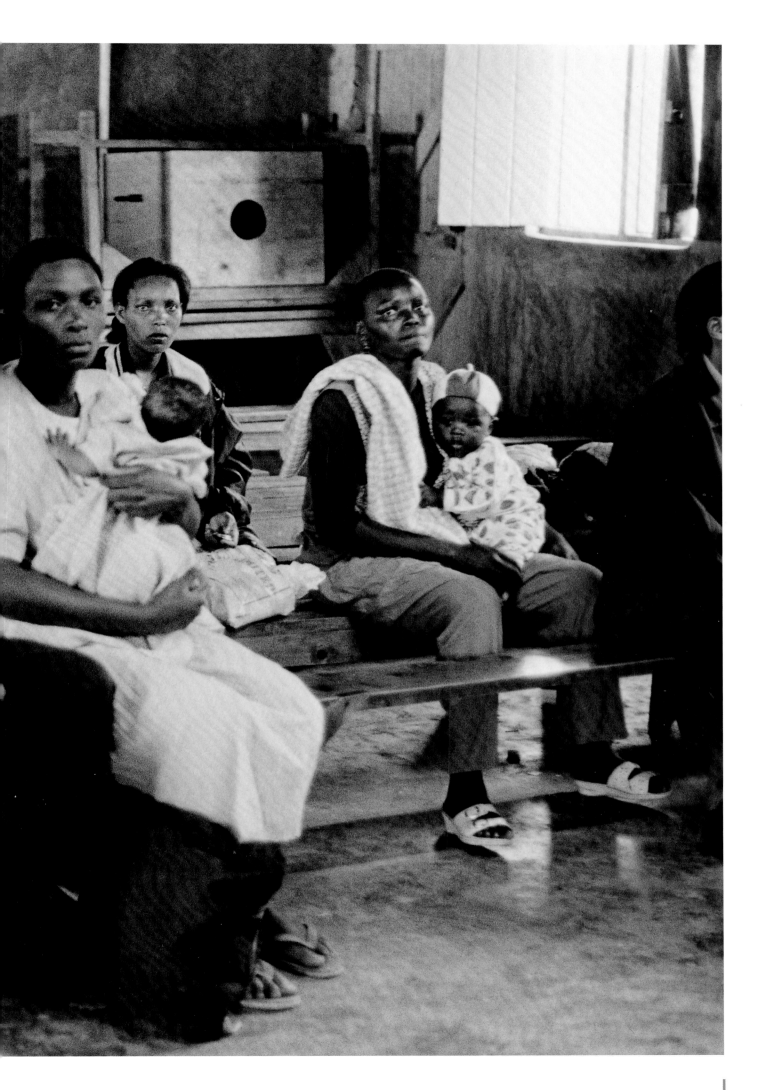

A medical clinic in the Mathare slum.

A wall and a reflection, Mathare slum.

The patients' lack of gratitude can make caregiving feel like a thankless task, but Ann understands the despair experienced by people living with AIDS in a profound and personal way. Four of her ten siblings—two sisters and two brothers—have died of AIDS. The first one to go was her twenty-six-year-old sister, Lucy, nine years ago. Ann went to her house everyday to nurse her and to help care for her two children. There were no antiretrovirals available back then, and the disease seized on her sister with a vengeance. She had ulcers in her stomach and boils on her skin, and in the late stages of her illness, when her body was so ravaged it could no longer function, she became incontinent. The few times Ann brought her to the clinic to see a doctor, she carried a bottle of perfume, which she sprayed on her sister continuously in an attempt to hide her stench. "At the time, AIDS was even more taboo than it is now. I was afraid to tell the rest of the family that my sister was dying of AIDS, so I said that she had stomach cancer. I was worried they would reject her."

Ann had to face the prospect of rejection herself when she first began extending herself to other community members as a caregiver. Every caregiver knows that she risks being perceived as HIV-positive herself, and shunned by her community. "If people see you walking into the home of an HIV-positive person, they assume that you are infected as well," says Ann. "When I began caregiving, I was afraid I would lose all of my friends. But I decided I had to have the courage to follow my convictions."

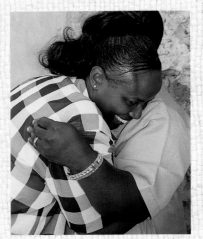

Ultimately, Ann's friends did not abandon her because of her decision. Rather, it opened up a much-needed dialogue about AIDS in her community. Merely through example, she has been able to erode some of the fear and ignorance surrounding the disease. "Community members see me, after all these years of caregiving, and I am still alive, I am still healthy," says Ann. "At the same time as we are helping people to fight the disease and to die with dignity, we are creating awareness that you can reach out to an AIDS patient. You can touch them and talk to them and treat them like a human being without putting your life at risk. I think that's the most important message we can bring to our community."

When I began caregiving, I was afraid I would lose all of my friends. But I decided I had to have the courage to follow my convictions.

PRECEDING
A schoolroom in Mathare.
THIS PAGE
Ann Wanjiru embracing Rose Omia.
OPPOSITE
Laundry day in Mathare.

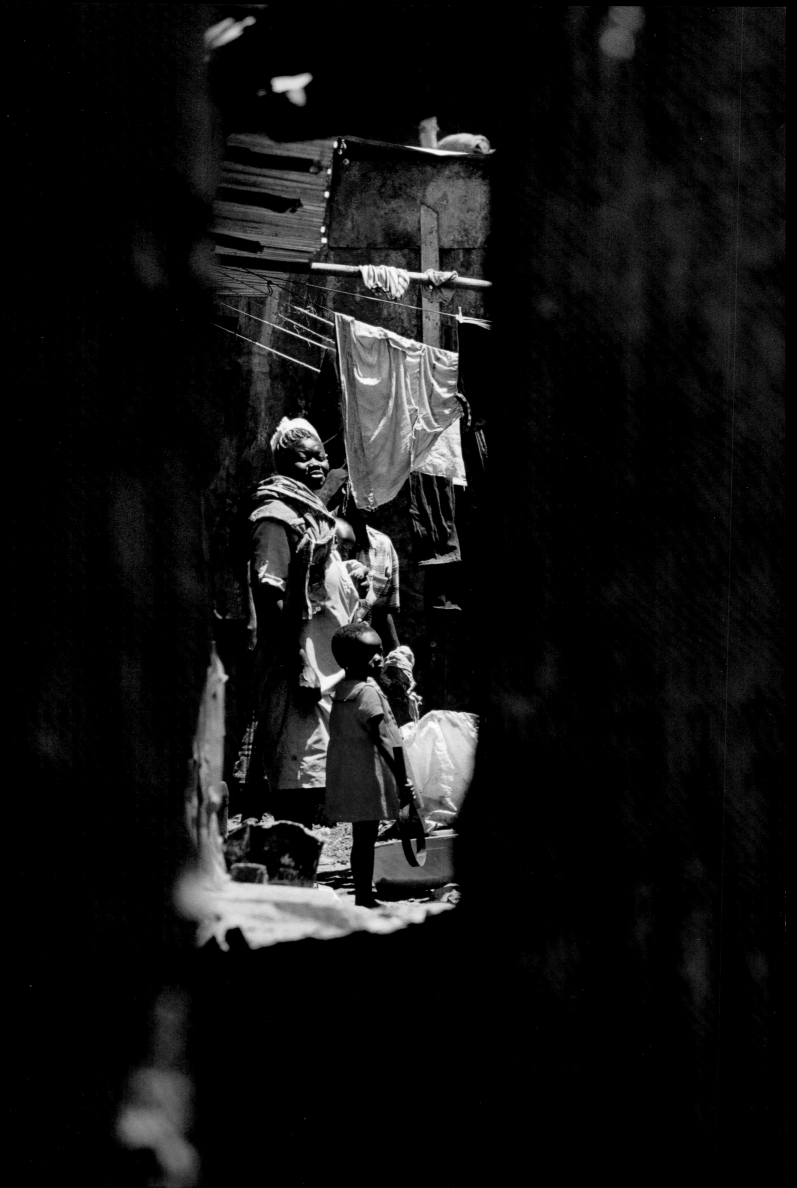

TOP **Mathare at night.** BOTTOM **Reflection in Mathare.**

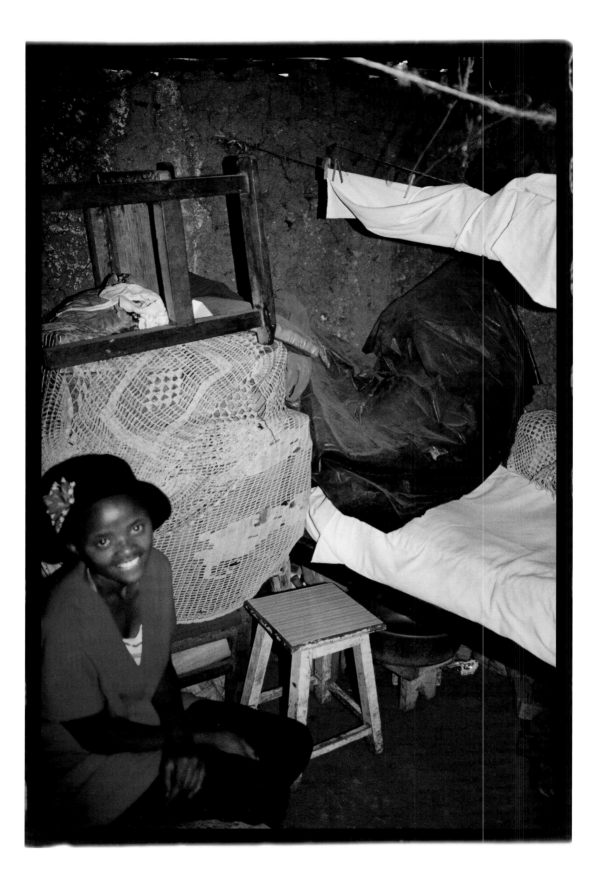

HISTORY OF REGION:

Africa's highest peak, Mt. Kilimanjaro, is located in Tanzania's mountainous north. The mainland, known as Tanganyika, also boasts a central plateau and coastal plains along the Indian Ocean. The Zanzibar islands of Tanzania are located off this eastern coast.

Human habitation of Tanzania was dated back more than two million years with the 20th-century discovery of human fossils in the Olduvai Gorge by Mary and Louis Leakey. Various nonindigenous people began migrating to the area around the first millenium AD. In the late 1700s and early 1800s, Zanzibar gained its notorious status as the center of the ivory and slave trades.

A German colony under stringent rule from the 1880s until 1919, the region then became a trust territory of the British, who governed indirectly through African leaders. Tanganyika gained independence in 1961, and in 1962 became a republic, with Jules Nyerere elected the first president. A year later Zanzibar became independent, and in 1964 the two regions merged to form the nation of Tanzania.

CURRENT SITUATION:

In 1995 Tanzania ended one-party rule with its first multiparty election. The ruling party, known as Chama cha Mapinduzi or CCM, easily won. In December 2005 Jakaya Mrisho Kikwete of the CCM was re-elected for a fourth term.

The 37,445,392 people of Tanzania share Swahili as their official language. They live in one of the poorest countries in the world, and, like other East-African citizens, suffer a high incidence of HIV and AIDS infection. The National Strategy for Growth and Reduction of Poverty or MKUKUTA was drawn in late 2005, and seeks to reduce income poverty, improve quality of life, and ensure good governance.

CONSERVATION
TANZANIA

EDINA YAHANA

When Edina Yahana was a child, the rainforest that surrounded her village of Kambai, in northeastern Tanzania, was dense with trees. Several times a week, she and her mother used to tramp into the forest's depths to gather firewood, mushrooms, and herbs. It was a mysterious place, tinged with stories of demons and ritual sacrifice.

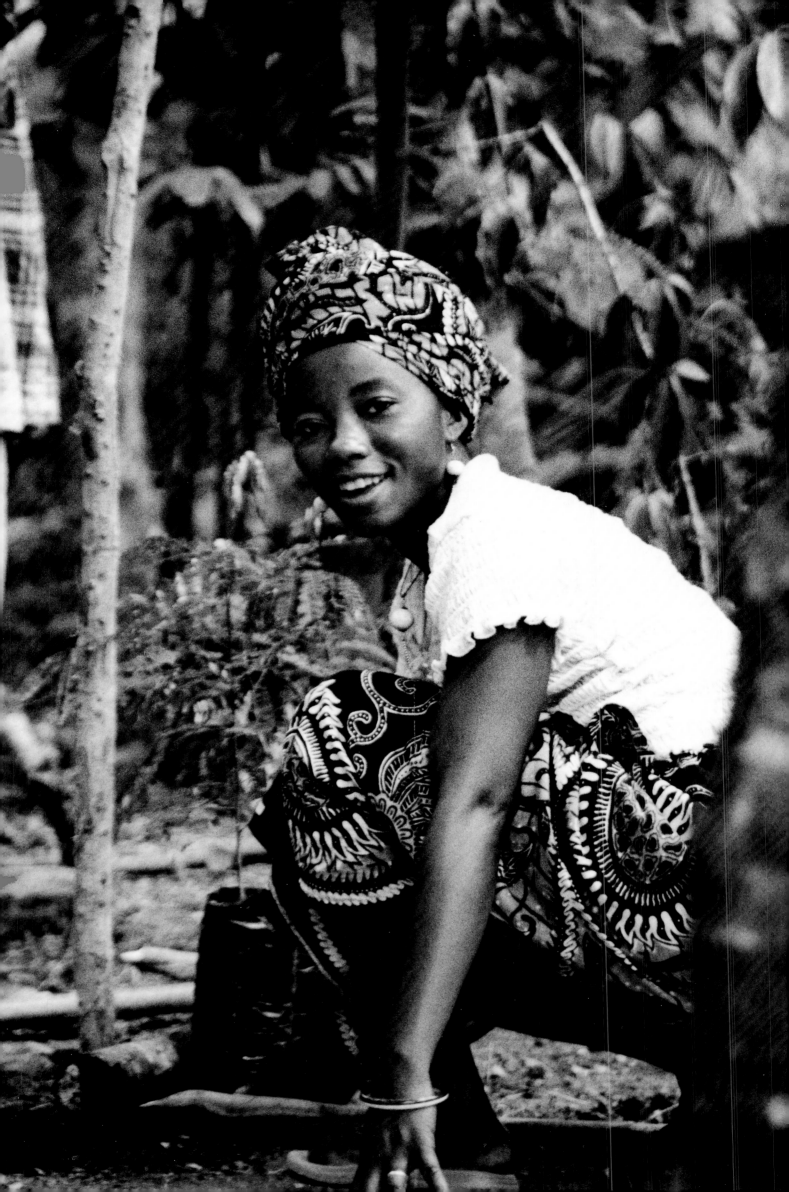

OPPOSITE
Edina Yahana transplanting seedlings in a new tree nursery.
THIS PAGE
TOP **Eastern Arc Rainforest.**
BOTTOM **A man logging trees for lumber.**

By the time she was fifteen, the forest no longer looked much like a forest. There were plenty of trees—teak, Rhodesian mahogany, almond trees, Spanish cedars—but between them were wide spaces, and when Edina looked up, she did not see the dark canopy of leaves that she remembered from earlier years. She saw fragmented pieces of sky through the latticed branches. The forest area in the Eastern Arc Mountains where Edina's village is located, as well as in the southern part of the range, is decreasing at an alarming rate. Since the 1970s, more than forty thousand hectares of forest have been destroyed. In the most ravaged area, one third of the forest has been cleared in the past fifty years. Trees are being harvested for timber and charcoal, chopped down to make way for sprawling tea plantations and farms, and burned down in forest fires.

Edina was only thirteen when she began working to remedy the situation. She had just finished middle school and was looking for a way to earn some money. Even as a child, she had been drawn to planting. She took pleasure in helping on the family farm, and recalls passing a grove of orange trees and begging her parents to let her start her own orchard. So when she heard that the Tanzania Forest Conservation Group (TFCG) was offering jobs to villagers to start tree nurseries so that they could begin replanting the forest, she leapt at the opportunity. The nursery that she started was a huge success. Within six months, Edina had produced three thousand healthy saplings from five hundred seedlings. Greatly impressed, a TFCG forester offered to send her to school for a certificate in forest management.

That was the moment when a means of earning money transformed into a mission for her. "When I began to understand how invaluable the forest is, and how endangered, I also began to understand how important it was to continue to raise and plant trees," Edina says. "I wanted to spread this knowledge throughout my community."

OPPOSITE
A tiny villager in Kwizute
learning to transplant saplings.

When I began to understand how invaluable the forest is, and how endangered ... I wanted to spread this knowledge throughout my community.

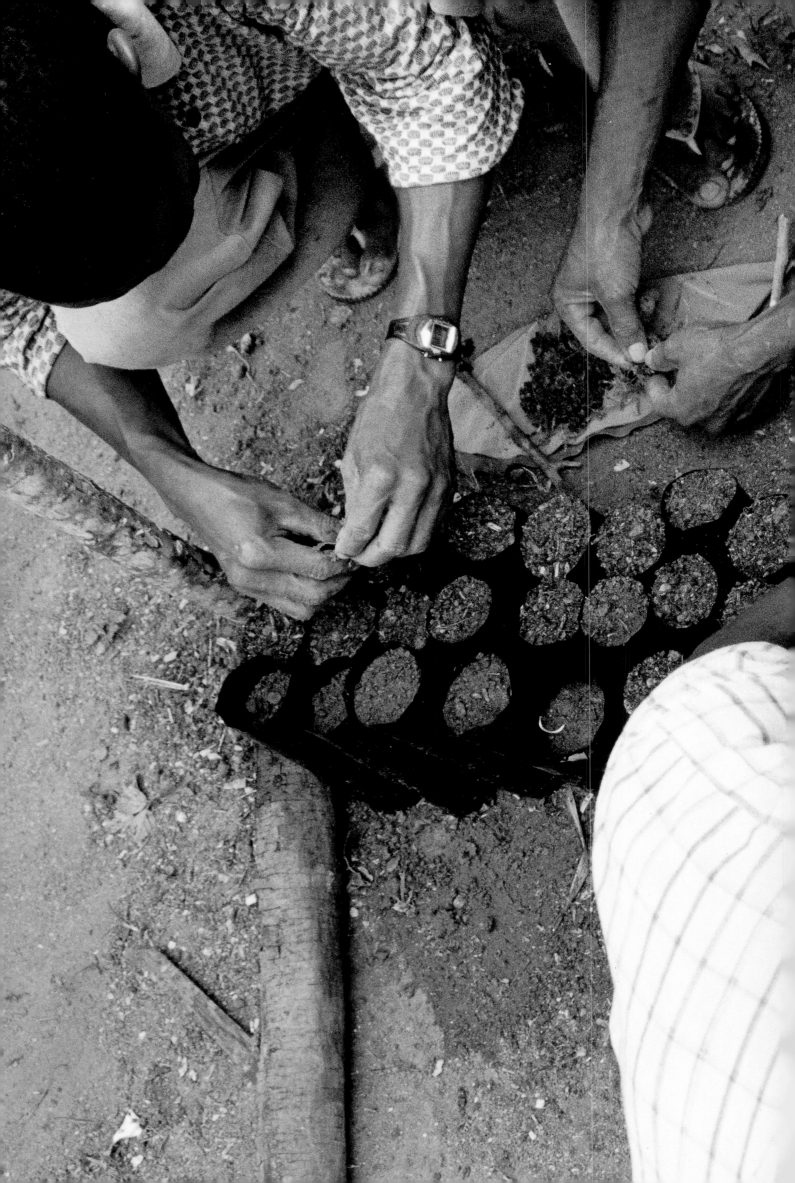

As an assistant forester for TFCG, Edina, who is now twenty-five, migrates to a different village in the Eastern Arc every few months to educate the villagers about both theoretical and practical aspects of conservation. She is the only woman among TFCG's five foresters in the region, which can be a challenge. Asking impoverished villagers to refrain from cutting down trees that they depend on for cooking, housing, and income, is itself difficult enough, but it is particularly difficult for a young woman in a patriarchal culture in which age is a measure of wisdom. Even after years of doing this kind of work, Edina is still apprehensive when she has to approach the chairman of a village—generally an esteemed elderly man—to ask his blessings to teach a conservation workshop. It is a process that requires two or three days of sweet-talking, and although Edina's proposal is rarely turned down, there are invariably a few detractors who deride her message, saying she is too young to be offering advice. "I think they do illegal logging for the timber companies," she says conspiratorially.

PRECEDING
Planting seedlings in Kwizute.

Once she is in teaching mode, Edina has a quiet confidence that belies her age. To demonstrate the impact that environmental destruction has had on their area, she starts with a simple but effective lesson. She asks the eldest members of the group if they remember what the forest looked like forty years ago. Invariably, they point far into the distance and talk about how the trees used to stretch to a faraway mountaintop, as far as the eye could see. "If this is the case," Edina says, "can you imagine what the forest will look like in another forty years if we continue to cut down trees at this rate?" The students nod gravely. It is a sobering thought.

When we visit she has spent the past couple of months teaching a group of twenty-five residents of the village of Kwizute to establish a tree nursery. The goal is to start replanting the forest, as well as to divert villagers from illegal logging by providing them with their own trees, to be grown on their own land. She deftly demonstrates how to measure and cut a birthing tube from a roll of shiny black plastic, pack it neatly with just the right amount of soil, and transplant the seedling from a seed bed to the tube. One by one, the students try to mimic her, their movements tentative, slightly awkward. Then she moves to another group to instruct them how to make their saplings hardy enough to survive in the wilderness by alternately exposing them to sunlight and protecting them with a "roof" made of fern fronds. Eventually, she will teach the villagers to transplant the mature saplings to the forest, or to their own farms, where they will grow into trees. Through TFCG, villagers in the Eastern Arc have planted more than four million trees in the past ten years. Edina will explain to her students that in replenishing the disappearing forest, they will help to attract and retain rainfall, as well as ensure sustainable harvesting of the medicinal herbs that they use in traditional medicine. She knows that in an impoverished village, making conservation practical is critical to its success, so she is vigilant about pointing out the ways in which it directly and immediately benefits villagers. "You can't convince a villager who is struggling for survival to save a tree if it's going to take away an economic advantage," says Edina. That is why TFCG has developed incentives that go beyond the benefits of conservation, which might seem too abstract to resonate with most villagers. Growing your own trees, she explains to her students, can provide you with fruit as well as a source of timber to sell for profit. She advises them to diversify their crops to help nourish the soil and avoid the soil erosion that results from monocultures. TFCG provides them with seedlings for banana trees, cardamom trees, and cinnamon trees, as well as for crops such as maize, beans, and cassava.

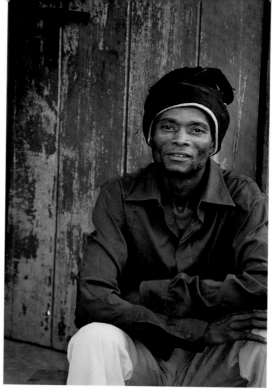

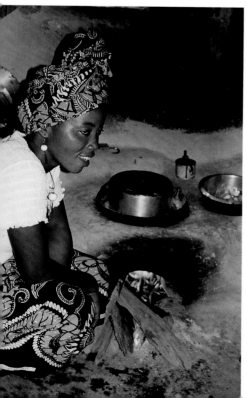

EPUKA VISHAWISHI:
KUPOKEA ZAWADI MBALI, MBALI (FEDHA)
ZISIZOKUWA NA SABABU MAALUMU
KUNAONGEZA KUJIWEKA KWENYE
MAZINGIRA YA HATARI

REWARDS INCREASES THE CHANCE OF RISK

OPPOSITE
Collecting firewood in the rainforest.
THIS PAGE
A village woman with machete.

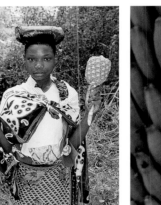

EAST USAMBARA
CATCHMENT FOREST PROJECT
KWEZITU SUB-STATION
(LONGUZA FOREST STATION)

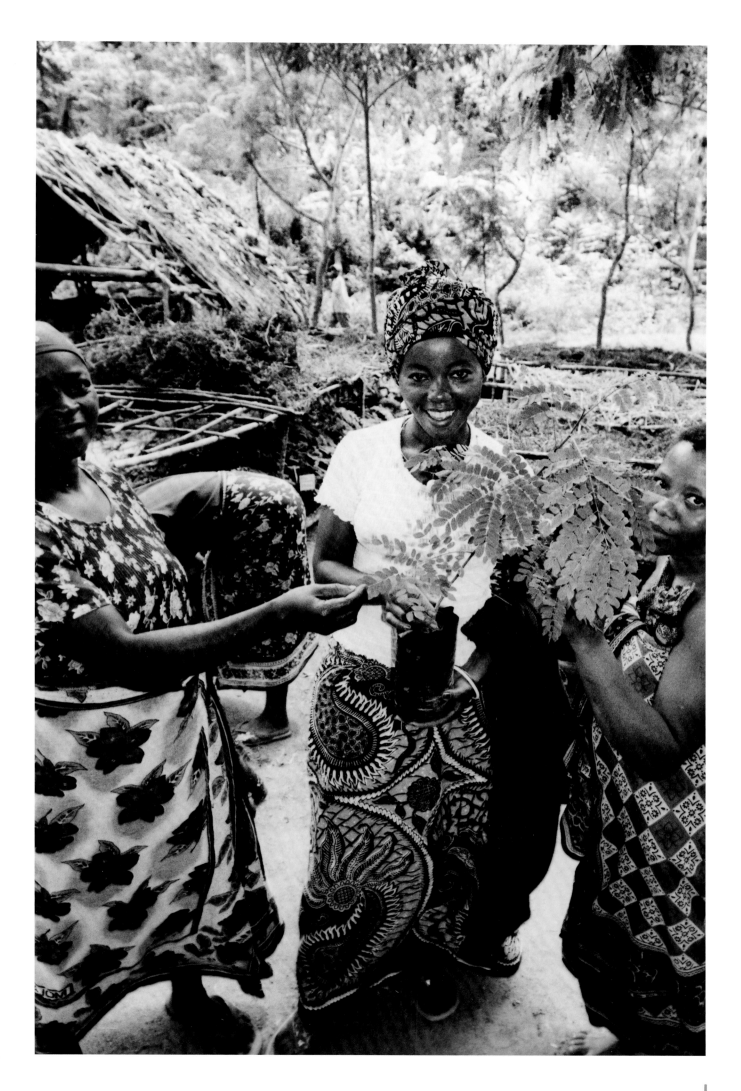

Edina and village women at the Kwezitu tree nursery.

You can't convince a villager who is struggling for survival to save a tree if it's going to take away an economic advantage.

All of TFCG's activities attempt to link conservation with income generation. Edina also helped launch a fish-farming project in Kwezitu, in which she led a group of villagers to dig eight terraced ponds near the village stream, which TFCG then stocked with tilapia. The ponds are a rainwater catchment area, and provide the fish farmers who maintain them with a source of revenue. With TFCG's butterfly farming project, Edina teaches novice butterfly farmers how to grow several varieties of plants on which butterflies feed and lay their eggs. Through TFCG, the farmers then sell the pupae to live butterfly exhibitors in Europe and the U.S., an enterprise that earned $17,350 in its first year of business, sixty-five percent of which went to the farmers. For the year 2005, it was projected that the project would earn up to $60,000. In addition to leading these three projects, Edina offers quick courses to teach villagers pragmatic conservation methods as well. One lesson focuses on how to construct a compact mud oven, which uses one-third less firewood than villagers' traditional method of cooking over an open fire. "I tell my students that this will allow them to spend less time and energy chopping wood and less time cooking," she says.

Edina at work.

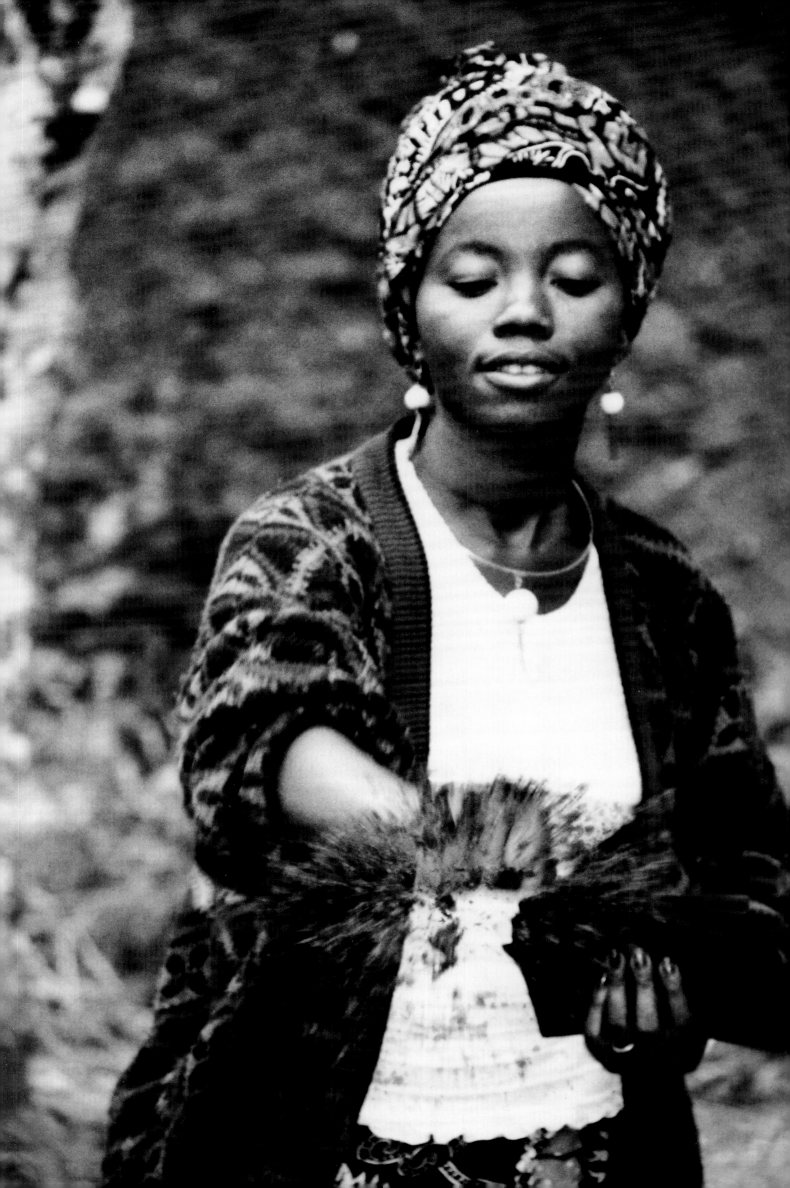

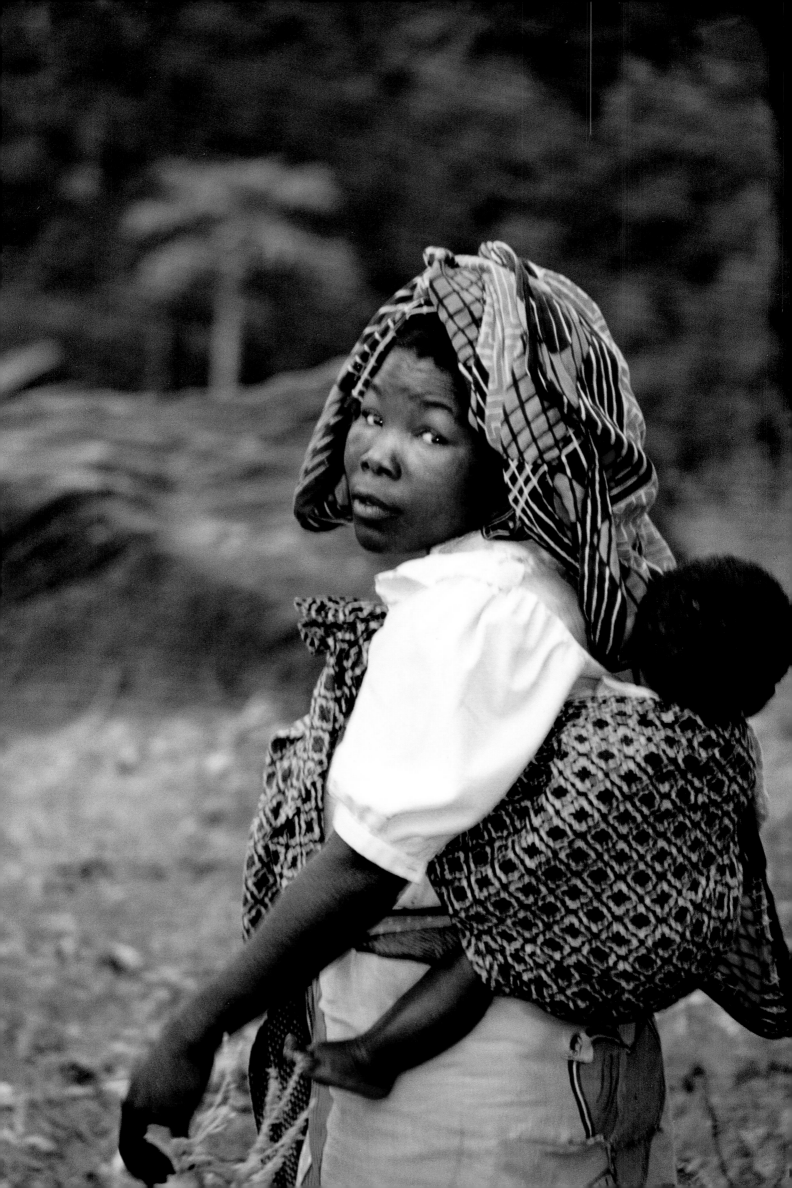

During her tenure in Kwezitu, Edina tries to inspire the youngest villagers to start thinking about conservation as well. At the village's white-washed cinderblock school, Edina does a short lecture, breaking environmental concepts down to their most basic components: the fact that trees attract rainfall and the fact that the Eastern Arc is one of the most important catchment areas in the country, providing twenty-five percent of the country's water. The students listen attentively, offer answers when prompted, and clap rhythmically when a fellow student gets an answer right. But afterward, Edina worries that the lesson did not sink in. "They were just words to the children," she says. "I'm not sure if they understand the way these concepts affect their lives." Before she moves on to the next village, she will help the students start a small tree nursery of their own. Her hope is that after going through the long, detailed process of growing their own saplings, the students will not take the forest for granted. That they will appreciate the value of every single tree. "We must pass this information on through the generations," says Edina. "If my grandparents had known what I know now about the environment, they would have passed that information on to my parents, who would have passed it on to me. If we start teaching this generation to value the environment now, by the time they are grandparents, there might once again be trees blanketing these mountains as far as the eye can see."

If we start teaching this generation to value the environment … there might once again be trees blanketing these mountains as far as the eye can see.

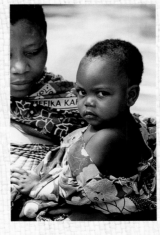

OPPOSITE AND RIGHT
Mothers and their children in the Usambara Mountains.
THIS PAGE
TOP **A classroom in Tanzania's Eastern Arc Rainforest.**
MIDDLE **The Usambara landscape.**

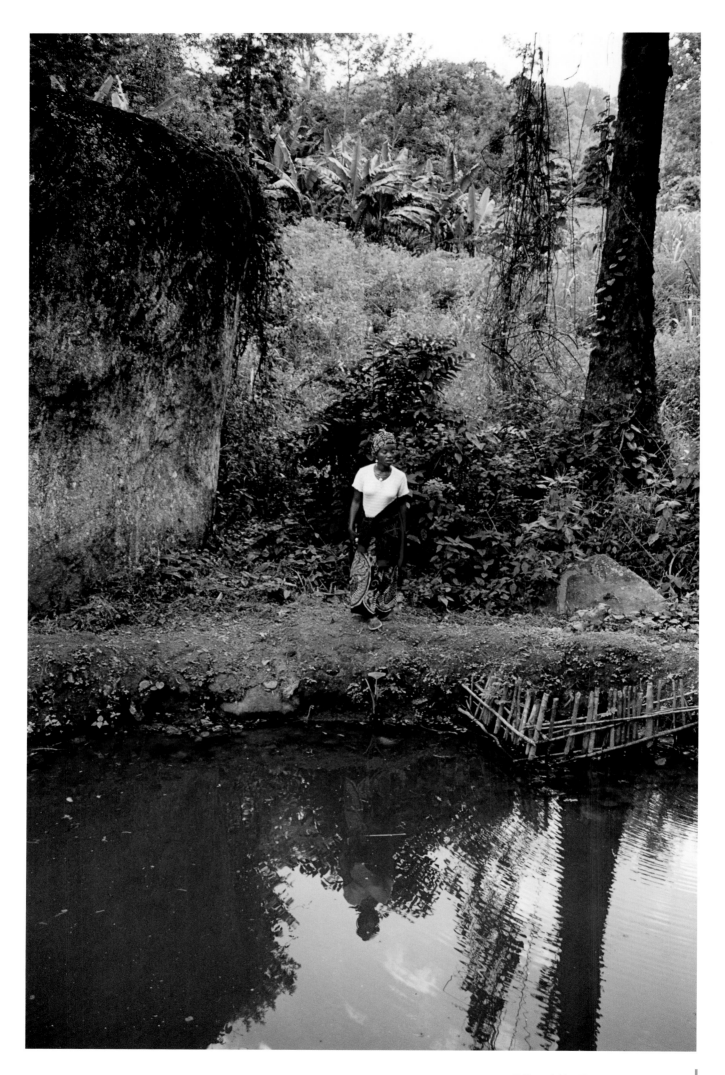

THIS PAGE Edina at the fishpond in Kwezitu.
OPPOSITE A lone tree in the Usambara Mountains.

HISTORY OF REGION:

Located on the continent's largest coastal plain, Mozambique of southeastern Africa borders the Mozambique Channel in the Indian Ocean. The Zambezi River flows through the center of the country and divides it in half.

San hunters and gatherers, ancestors of the Khoisani, lived in the region prior to the migration of Bantu-speaking people in the first century AD. Bantu trading ports with strong Arab influence and Arab settlements existed along the coast for centuries before the Portuguese arrived in 1498. The Portuguese held power for the next 500 years. In the early 1960s the Front for the Liberation of Mozambique (FRELIMO) was formed. Ten years of intermittent warfare resulted in independence on June 25, 1975.

Mozambique became a one-party state, allied to the Soviet bloc. Economic collapse, severe drought, and civil war followed its creation. In 1990 the ruling FRELIMO party instituted a new constitution, a free-market economy, and multi-party elections, and the civil war ended two years later with UN assistance. More than 1.7 million Mozambican refugees returned to the republic, and another 4 million internally displaced citizens went back to their areas of origin.

CURRENT SITUATION:

Mozambique is home to 10 major ethnic groups, the largest of which are the Makua and Tsonga. Many African languages are spoken by Mozambique's 19,686,505 people, with Portuguese being their official language. Most groups have retained indigenous cultures based on subsistence agriculture. Non-African people make up less than 1% of the population.

Although poverty and the AIDS epidemic remain serious threats, economic headway has been gained by Mozambique. In 2004 Joaquim Chissano stepped down after 18 years in office, and was succeeded by Armando Emilio Guebuza. He is intent on continuing on the path of reform.

HUNGER
MOZAMBIQUE

CELINA COSSA

There was a time in Mozambique not so long ago when most people only day-dreamed about eating meat, and milk was reserved exclusively for infants. Food was strictly rationed. People began to line up for rice at night and sometimes when they got to the front of the line the next morning, there was nothing left. Cabbage was the only nourishment Mozambicans could count on, so much so that it was nicknamed, "if it weren't for you," meaning, "if it weren't for you, we would starve."

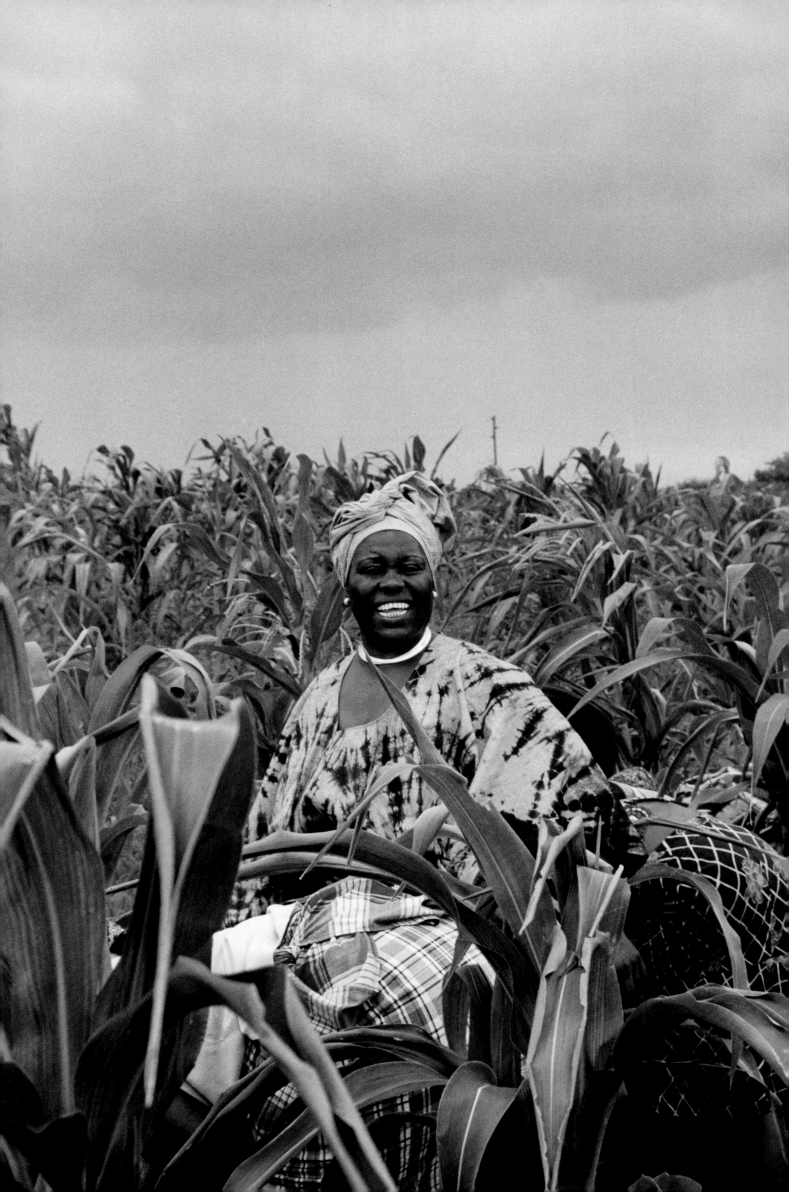

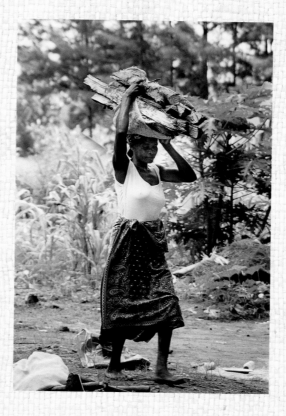

That was the mid-1970s, and the country was embroiled in a civil war that would last for sixteen years. Every day, more of the country's farmland was being destroyed by rebel forces or converted into battlefields. Farmers were afraid to work in the field, anxious about landmines and mortar attacks. Agricultural production plummeted after the country was granted independence in 1975, and the Portuguese had gone home, leaving a dearth of skilled farmers.

In 1980, the government passed a law subsidizing agricultural cooperatives in hopes of boosting food production, and exhorted its citizens to start farming to prevent starvation. At the time, Celina Cossa was a schoolteacher, but the call to go back to the land resonated with her. When Celina was a child as young as eight, her grandmother used put her to work planting vegetables whenever she visited. Celina's parents worked industrial jobs, but her grandparents were farmers. Her grandmother wanted her granddaughter to understand in a palpable way where she came from. "For a woman to be complete," she used to tell Celina, "she must hold a hoe and till the land."

Celina was a shy twenty-five-year-old when she decided to devote herself to addressing the hunger crisis in her country by joining an agricultural cooperative on the outskirts of Maputo. At the time, she trembled at the thought of public speaking, but her colleagues clearly saw a latent leader in her when they elected her president of the cooperative. She wept when it was announced that she had been elected, unsure that she was up to the task, but an elderly women comforted her, then offered some stern advice. "Never forget that you came out of a muddy field," she said, shaking a finger at her, "even when you are wearing nail polish and meeting with the president."

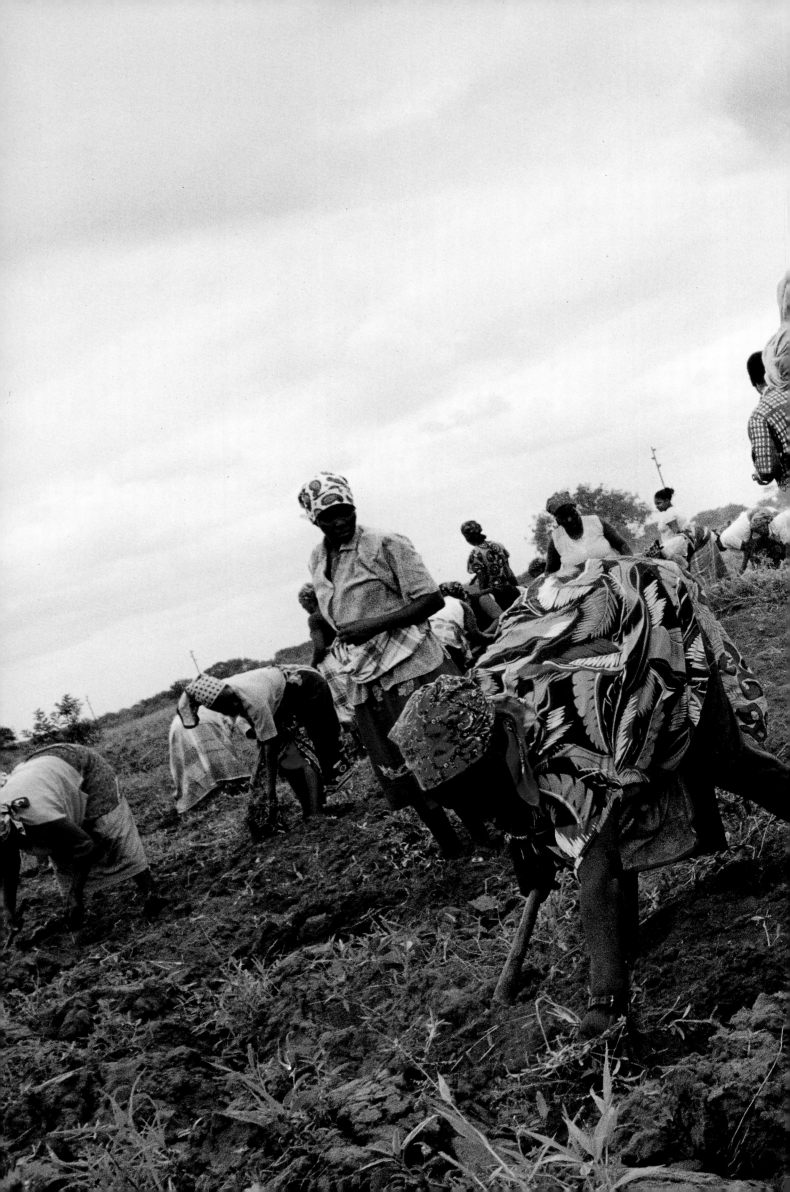

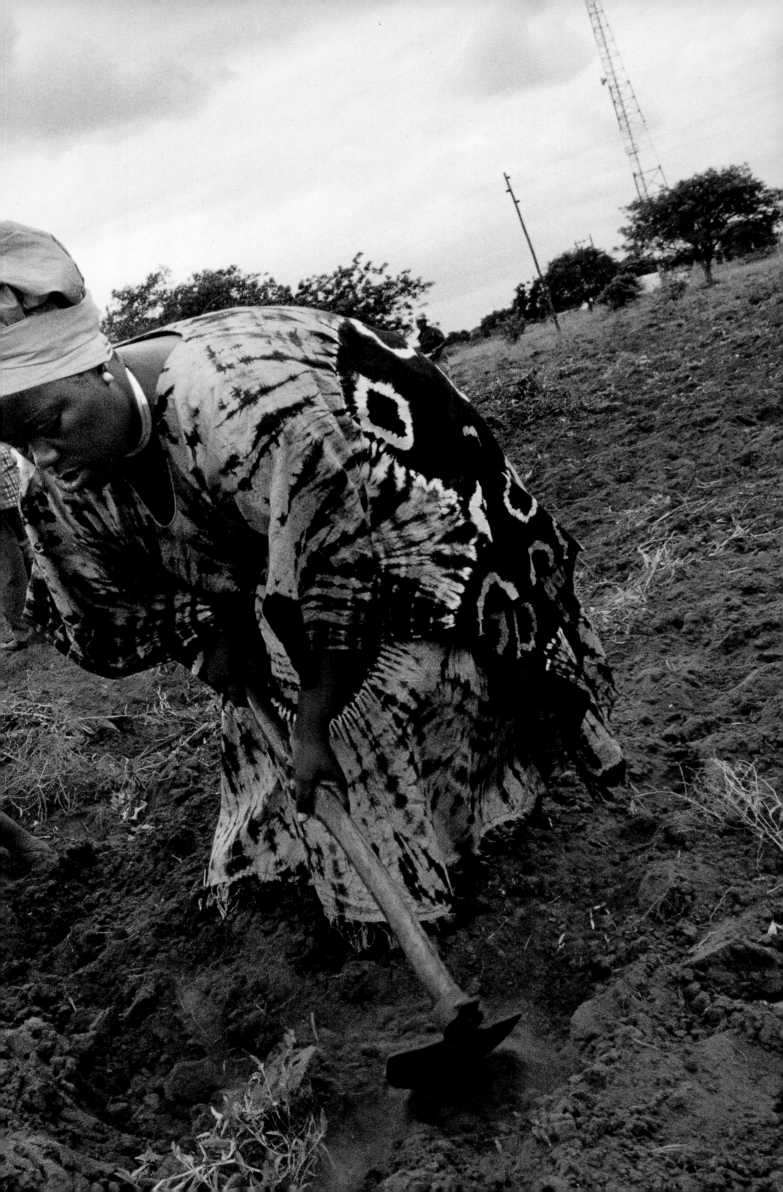

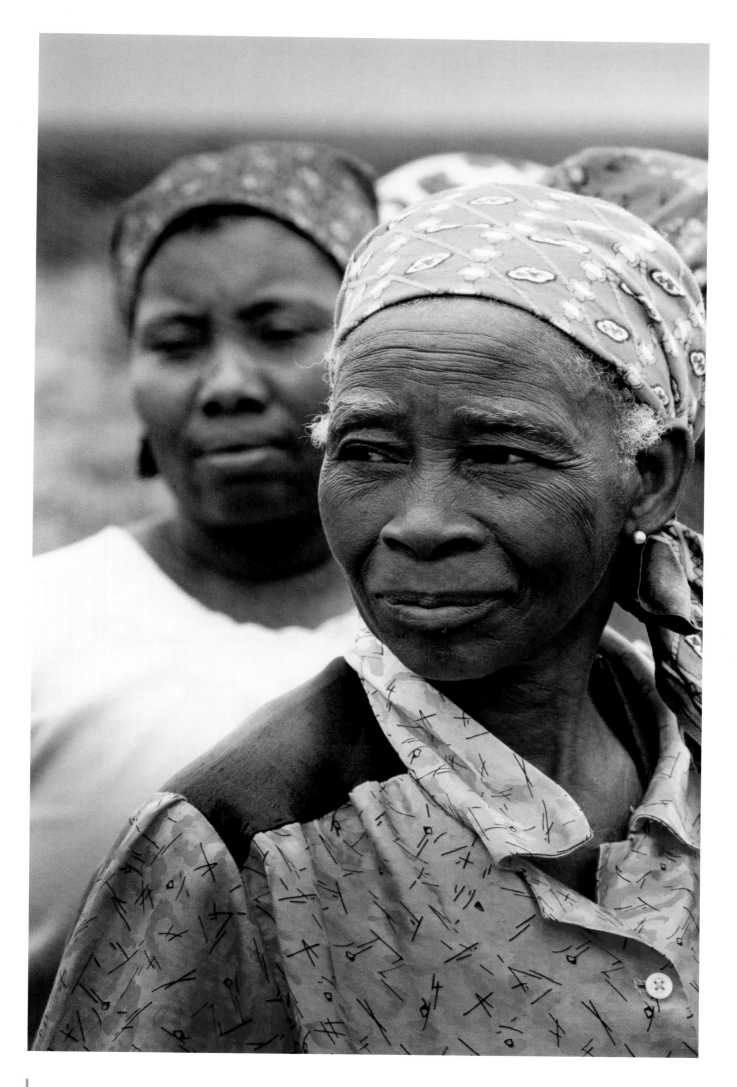

Women farmers outside Maputo.

Twenty-six years later, at age fifty-one, Celina has helped grow the cooperative from a group of seven farms to a union of 250 collectives, called the General Union of Cooperatives (UCG), which produces enough food to feed its six thousand members—many of them impoverished, illiterate women—and their families, as well as a hefty surplus that provides them with an income. She has led the co-op through the post-independence food crisis, civil war, and floods that devastated more than one third of the country; and she has diversified its services and production with the vision of a skilled entrepreneur, all the while maintaining its collective nature.

One hot, overcast day, Celina takes us on a tour of the various enterprises that she has helped kick-start as UGC president. We visit several vegetable farms, where we are greeted by dozens of peasant women with calloused hands and deeply lined faces. They are bent low over the fields of maize, chopping at weeds with short-handled hoes, and singing socialist folk songs proclaiming their unity. We visit a fruit farm where rosy mangoes hang pendulously from the branches of trees; a chicken breeding farm with hundreds of hens sitting atop eggs while roosters wander around impatiently; a meticulously clean slaughterhouse; a cashew nursery where saplings are planted in tight, neat rows, and a cashew processing plant.

Exporting cashews is the UGC's first venture into export, but poultry production is its biggest income generator. In 1987, Celina realized that raising chickens was much more cost-efficient than raising pigs, which had been the primary source of meat for the few Mozambicans who could afford it. Under the tutelage of a poultry farmer, she learned how to run a breeding farm so that the UGC could provide members with chicken houses and day-old chicks on credit. In twenty-two days, a chick is ready to be turned into dinner for a member's family or sold at the market. Families who previously could not afford to educate their children now use the proceeds from these sales for school fees. Others have bought small houses with help from the cooperative's savings and loan program. For many, working with the co-op has allowed them to quintuple their earnings. Members are encouraged to keep some of their profit in the cooperative's savings and loan, so that when hard times strike—as they inevitably do—they can draw on their savings. UGC's savings and loan program also gives members the opportunity to borrow money to start small businesses. It offers them options where previously they had none.

Never forget that you came out of a muddy field, even when you are wearing nail polish and meeting with the president.

OPPOSITE
Harvesting watermelons.
OVERLEAF
The cashew-tree nursery.

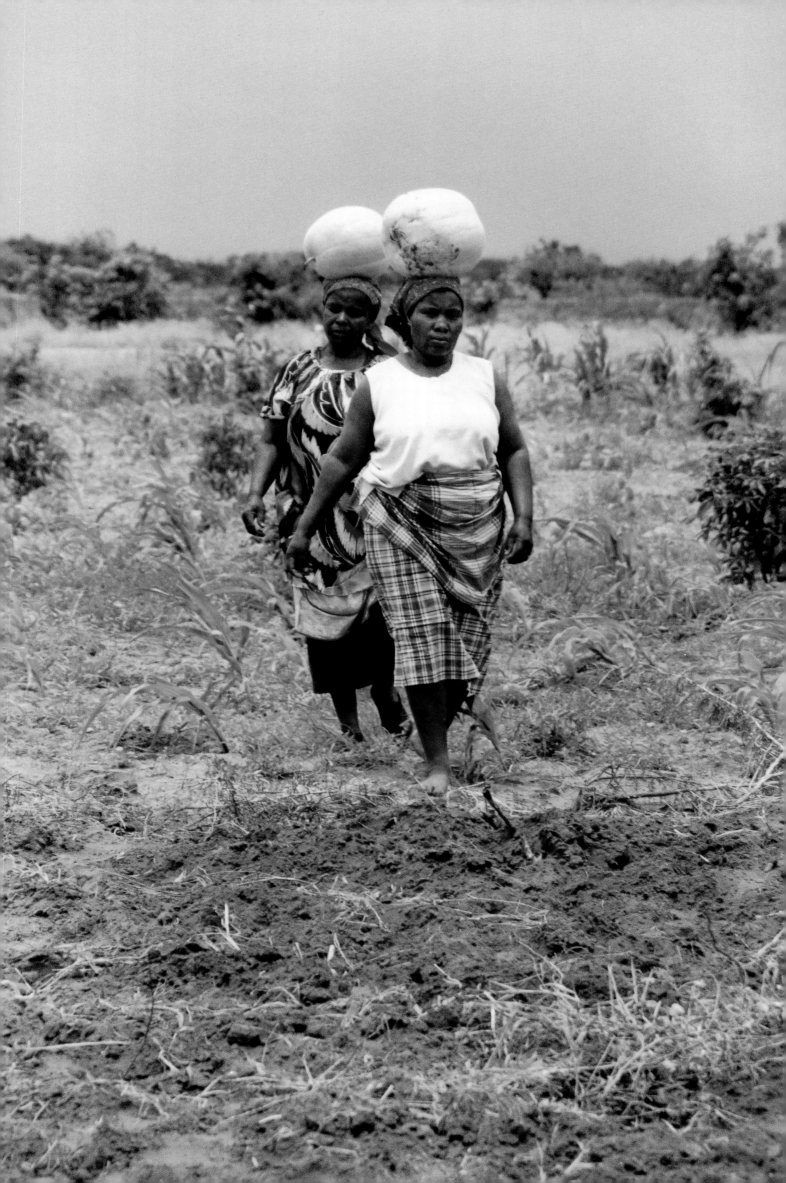

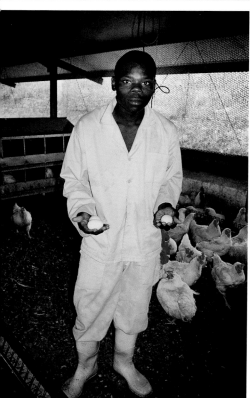

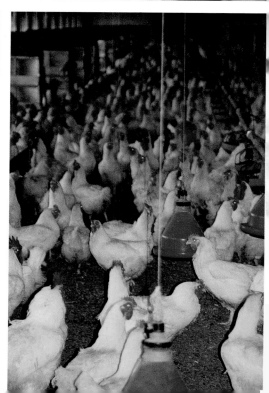

OVERLEAF
The chicken-breeding farm.

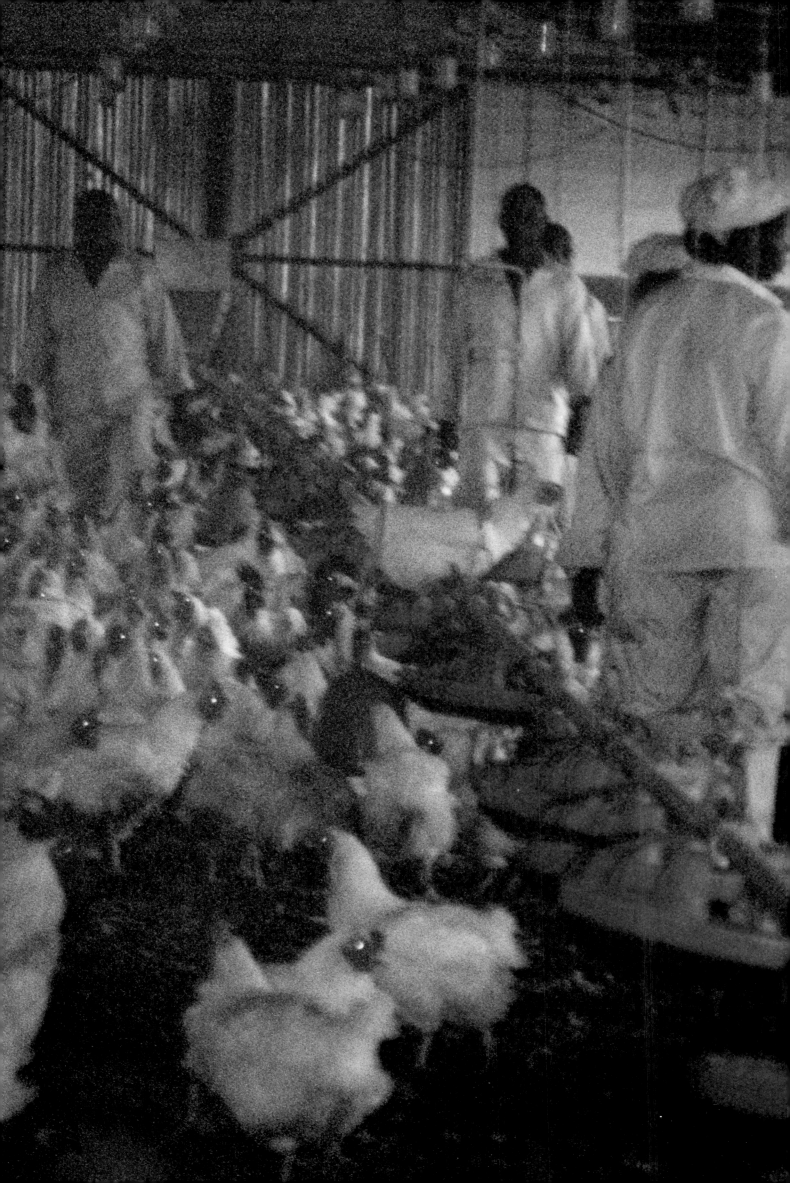

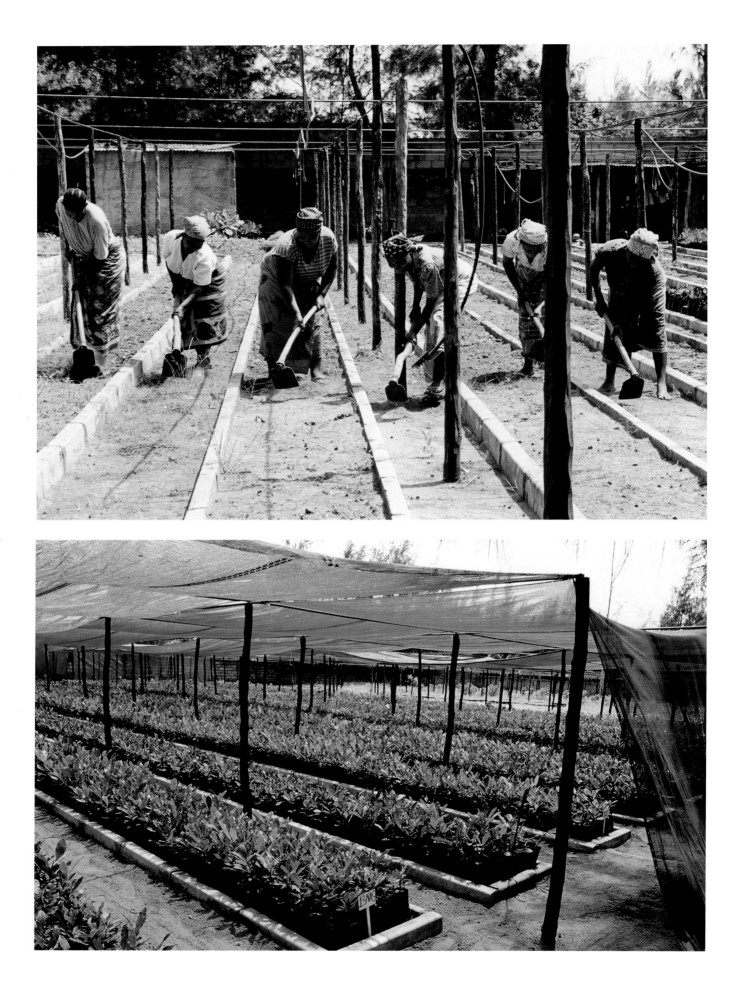

The cashew-tree nursery.

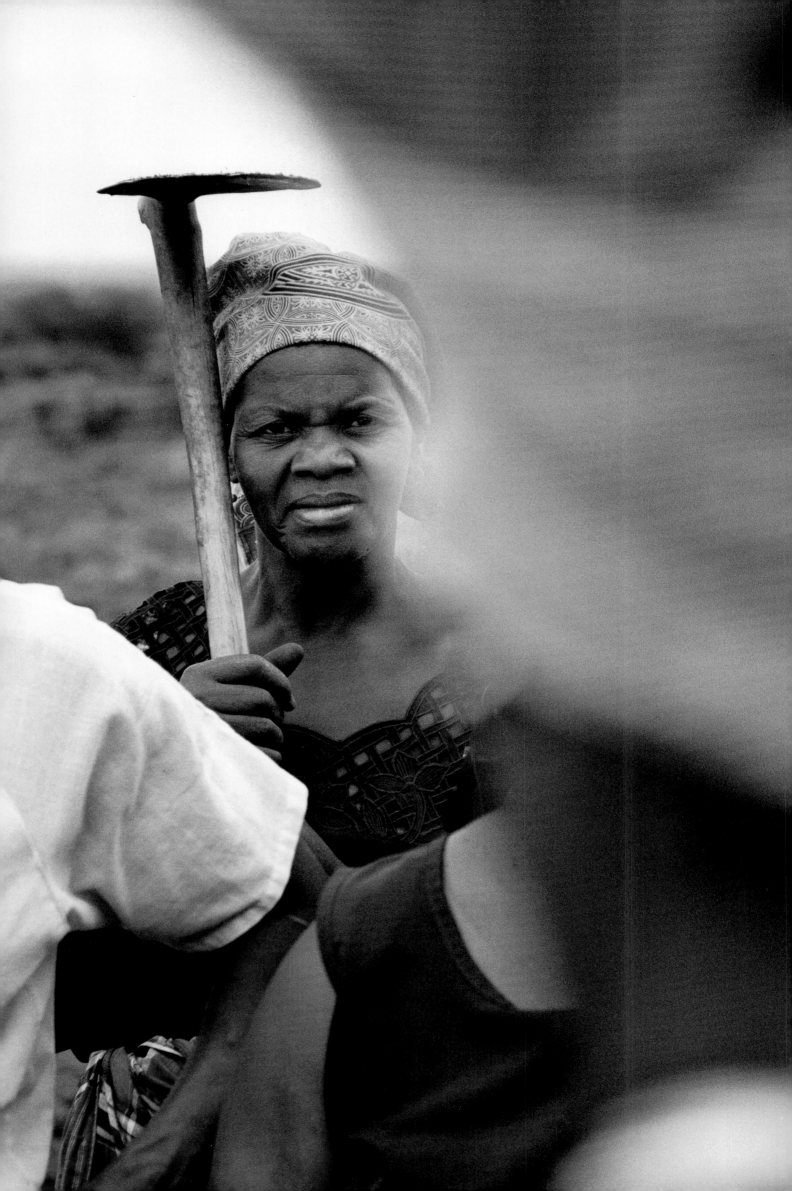

Now we always have enough food and I have camaraderie when I work.

But the cooperative provides workers with more than financial benefits. Madeline Munguabe, a tall woman with ropey arm muscles, dressed in a tank top and flowered headscarf, says working alongside other women gives her much-needed moral support. "I lost my husband in the war," she says, "and after that I was so lonely and struggling to feed my children. Now we always have enough food, and I have camaraderie when I work. My friends here inspire me. We sing while we're tilling the fields, we work hard but we enjoy ourselves."

Celina seems uncannily comfortable straddling the two worlds that she inhabits. In 1998, she was awarded the Hunger Project's prestigious Africa Prize, and her colleagues jokingly call her Dr. Celina, although she only has a primary school education. "I used to correct them, but now I just accept it." Several times, she has been flown to Europe and the United States. to give presentations in chilled auditoriums filled with diplomats. But international recognition has not affected her populist spirit. She never speaks of her own accomplishments—it is always "our accomplishments," referring to the body of workers that she represents. She donated the entirety of the fifty-thousand dollar Africa Prize to the UGC, although it made some people in her family grumble. "That prize was your luck," they said to her. "No," she insisted, "it was the UGC that made that luck possible for me." She makes a point of personally visiting every one of the 250 collectives around the country each year, and she is beloved by the peasant farmers of the cooperative for her humility and accessibility and for the way she sings and dances with them when she stops by to visit. "Celina doesn't stay in the office," says Madeline Munguage. "She comes to the field to visit us and to listen to our concerns and help us realize our dreams."

Standing beneath the mango tree where she held the UGC's first meeting, dressed in a shimmering gold caftan and headscarf, Celina addresses her constituents with the confidence and charisma of a seasoned politician. "What we have done through this collective is change our mindset," she says. "We used to think poverty was our destiny. We have learned that we can provide for ourselves, that we can make life better for our families. We have expectations for ourselves now, and we cannot let them die."

OPPOSITE
One UGC's 6,000 farmers.
THIS PAGE
Women working at one of the UGC's fruit tree farms.

We used to think poverty was our destiny... We have expectations for ourselves now, and we cannot let them die.

PRECEDING
Celina Cossa with members
of the cooperative.
THIS PAGE
A woman with a cassava root.
OPPOSITE
The symbol of the fight against
AIDS painted on a tree.

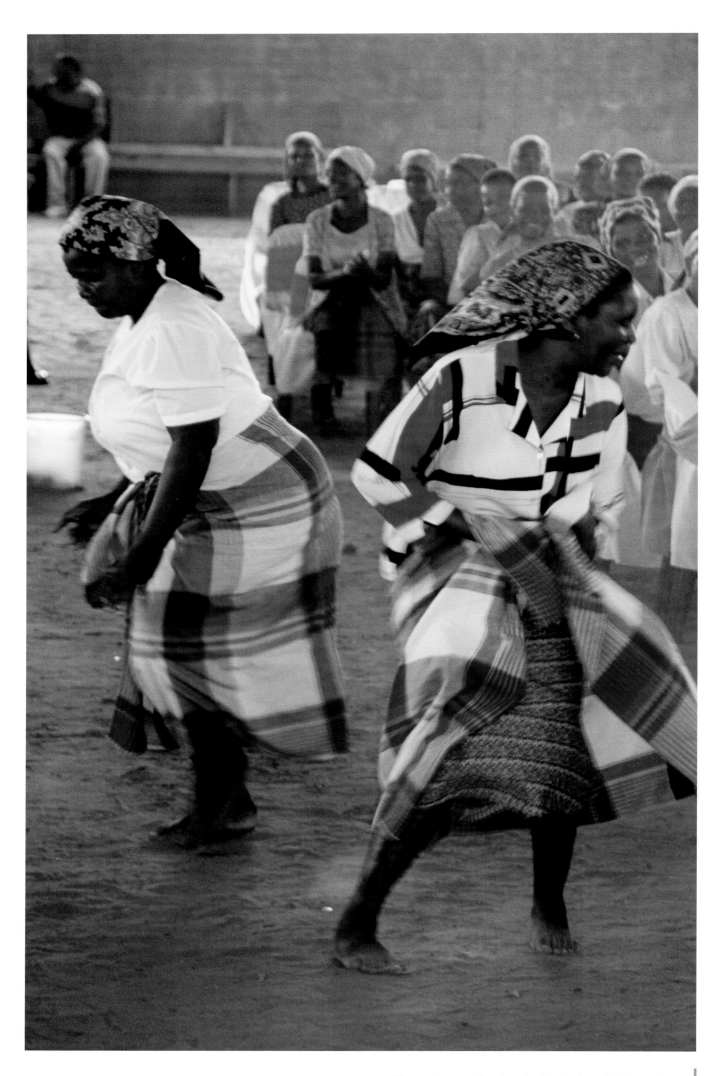

THIS PAGE **Women farmers dancing at a lunch given for the authors.**
OPPOSITE **Celina.**

A small, landlocked nation in Central Africa, Rwanda is mostly savannah grassland, with a rugged relief of steep mountains and deep valleys.

The pygmoid people known as the Twas dominated the region before the arrival of the Hutus in AD 1000. Tutsi cattle breeders migrated to the area in the 15th century and gained control, establishing a monarchy and subjugating the Hutus. In 1890 Germany took over without resistance from the people. During World War I Belgian forces occupied Rwanda, and in 1919 Belgian rule began.

Fighting broke out between the Hutus and Tutsis in 1957 when the majority Hutus called for changes in Rwanda's power structure. The Hutus emerged as the victors, and some 150,000 Tutsis fled to neighboring countries. Belgium granted the Hutu-lead Republic of Rwanda independence on July 1, 1962. The Rwanda Patriotic Front, a rebel group formed by children of Tutsi refugees, began a civil war in 1990, and in April 1994 came the genocide of about one million Tutsis and moderate Hutus. Tutsi rebels defeated the Hutus in July 1994, and roughly 2 million Hutus fled.

CURRENT SITUATION:

Rwanda is the most densely populated country in Africa. Its 8,648,248 people are 84% Hutu, 15% Tutsi, and 1% Twa. Almost three-quarters of them are Christian. Agriculture is the means of support for 90% of the land.

Rwanda held its first post-genocide elections in 2003, with the Tutsi Paul Kagome elected as president. Today Rwanda faces poverty, energy shortages, the threat of some 10,000 Hutu rebels in the Democratic Republic of the Congo who wish to retake the country, tension caused by recent involvement in two nearby wars, countless ongoing trials of accused genocide participants, and an inability to compensate survivors still in need of reparation.

CONFLICT RESOLUTION
RWANDA

PASCASIE MUKAMUNIGO

The skulls of the dead are meticulously arranged on long wooden tables at the Ruhashya Memorial Site in Rwanda's Butare province. They are housed inside an austere concrete building, table after table of them, lined up temple to temple. Beside the skulls are tables filled with bones—femurs and tibulas and radiuses, pristine and lovely as if they had just washed up from the sea. One table is reserved for fragments: a curved piece of jaw, a shard of finger. On another, a rounded piece of skull holds a handful of yellowing teeth like some sort of macabre candy dish.

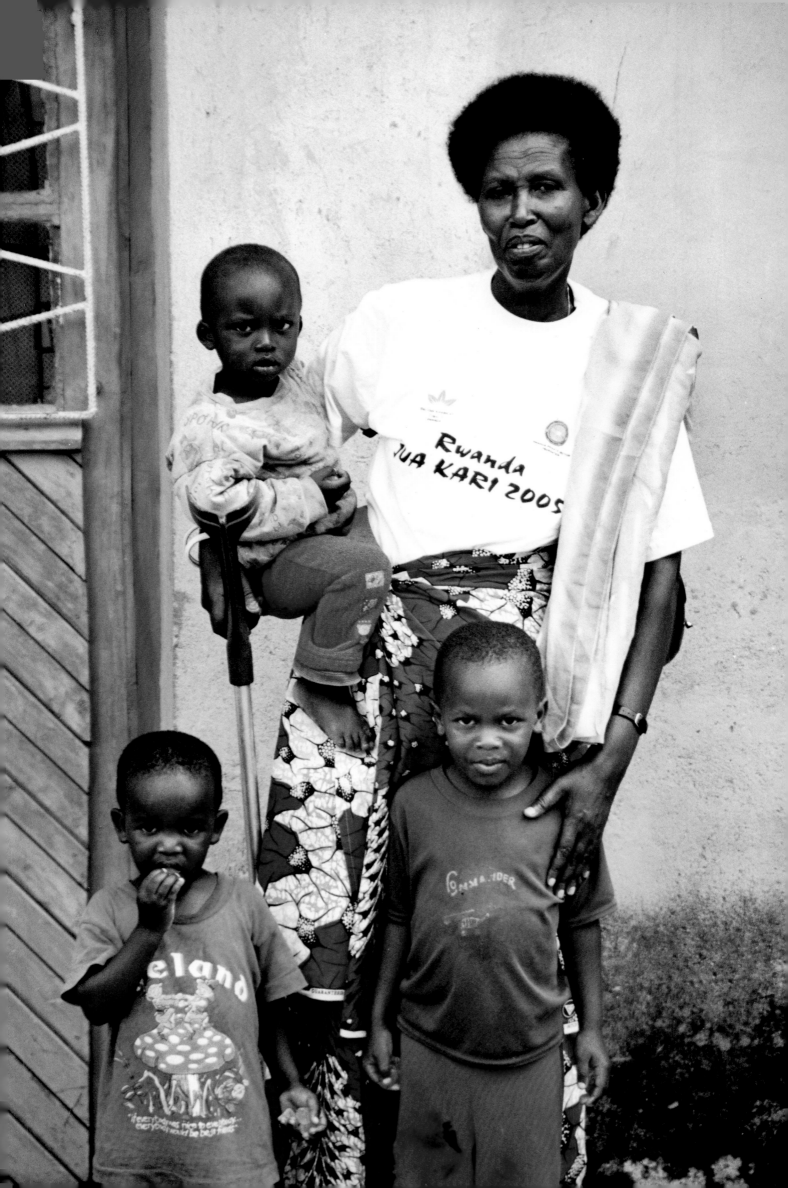

Outside of the building are more remains—32,000 bodies in all, packed into crude wooden coffins, lowered into the earth, covered with slabs of concrete. Pascasie Mukamunigo's mother is buried here, and so is her brother. Her husband and children might be, too, but she cannot be sure. Like most who lost loved ones in the Rwandan genocide, she does not know exactly where the killers disposed of her family's bodies after mutilating them. The corpses were dumped into mass graves where they decomposed into anonymity. By the time they were exhumed, most were unidentifiable, unless a relative was lucky enough to find a scrap of clothing, or an ID card, perhaps, that would at least tell them that their son or sister or uncle was somewhere in the tangle of bones.

More than one million people were killed in Rwanda over a period of one hundred days between April and July of 1994. It was a hysteria that provoked doctors to kill their patients and husbands to kill their wives, simply for being on the wrong side of the ethnic divide between Hutus and Tutsis, and to kill them in the most brutally intimate way: hacking them to death with machetes, close enough to see the expressions on their faces. Today, eleven years later, it is hard to imagine Rwanda in the grip of such violence. The landscape is lush and gentle, the scenes along the side of the road pastoral. Women harvest soy beans in the valleys, graying men peddle ancient bicycles up steep hills, a young boy in a sleepy village tries out a rustic wooden scooter, hand carved especially for him.

Pascasie is a master basket weaver, and on the day that the genocide began, she had gone to the capital city of Kigali to sell baskets at the marketplace. That evening, the Hutu president of Rwanda's plane was shot down, and the Hutu Power militia began wantonly killing anyone perceived as an enemy—members of the Tutsi minority group, or Hutus suspected of sympathizing with them. Pascasie frantically tried to get home to her village, but bus service had been suspended. She took shelter in a Catholic church called Sainte Famille, along with dozens of other Kigali residents. Throughout the one-hundred-day killing spree, Pascasie remained sequestered in the church. It was hardly a refuge. While there, she saw humanity at its worst, acts of violence so disturbing that today, eleven years later, it makes her weep to describe them. Every day, grenades were lobbed into the church and guns fired randomly into the crowd, maiming or killing those in their path. Once, Pascasie was standing next to a mother nursing her baby when the woman was hit with a grenade. The baby's mouth filled with blood, Pascasie tells me, her tapered fingers tapping her mouth. Every day, members of the Hutu militia would read off a list of people's names and drag them out of the church crying and screaming. They never returned. "I kept praying that I would die so I wouldn't have to see these horrible things anymore," says Pascasie.

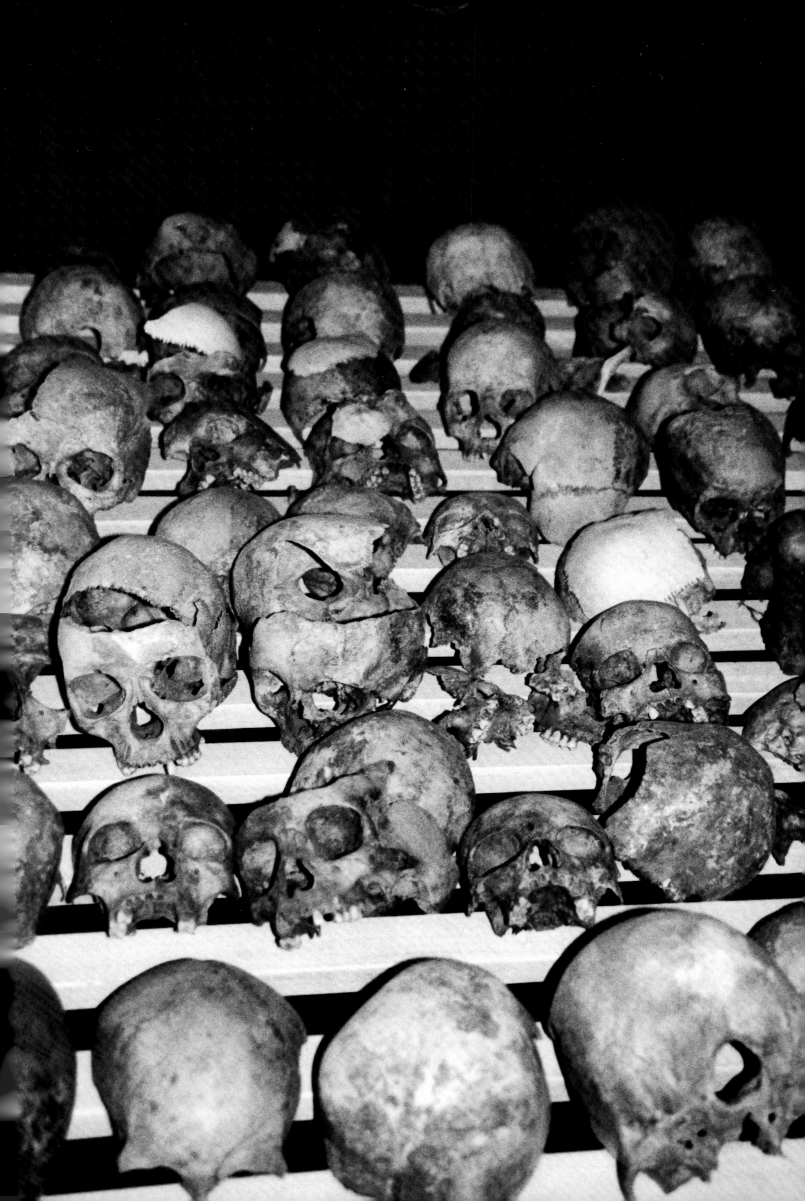

When Pascasie finally made it back to her village three months later, it was eerily quiet, and her house was burned to the ground. A neighbor offered her shelter in her house and, for months, Pascasie lived there on charity, waiting to hear news of her missing mother, husband, and her ten children, hoping for the best, expecting the worst, until finally a neighbor returned and confirmed her fears: twelve members of her family were dead. Only her three eldest sons were still alive. In a desperate bid for survival, they had joined the Tutsi army, the RPF, in the months leading up to the genocide, so they were not in the village on the day of the massacre.

Pascasie is sixty-one years old, a tall, slender javelin of a woman who walks with a slight limp; her knees and ankles are damaged, the result of months of crouching to hide from marauding soldiers during the genocide. Before the war, Pascasie ran a basket-weaving collective called, "Let's Work to Help Each Other," made up of twenty-four weavers, both Hutu and Tutsi, who collaborated to fill orders from abroad. After six years, she had more than 600 dollars saved in her personal bank account. When her house was burned down during the genocide, her bank book went with it. With no way to verify the amount she had had in her savings account, the bank would not turn over her money. At age fifty, Pascasie had to start over again. Since basket weaving is what she knew, that is what she fell back on.

In 1997, she began recruiting members to relaunch the collective. It was not a simple matter of inviting former members to reassemble. Many of the Tutsis were dead, and people were wary of one another. "Everyone was hiding from each other back then," says Pascasie. "People would see me approaching and run. Hutus thought I was angry with them and might seek revenge, and Tutsis who didn't know me were afraid that I might be a Hutu who had killed their family." But Pascasie realized that she and her neighbors could not go on living as enemies. She began to think of resuscitating the collective as more than a financial opportunity; it became a vehicle for healing the injuries of the past.

To help put those she approached at ease, she asked a Hutu neighbor to assist her. "With two of us, one Hutu and one Tutsi, people began to open up to us, little by little." That first year, she recruited only seven members. By the second year, she had forty members, and by the third year, that number had doubled. Now, eight years later, there are 120 members in the association, which she renamed Agaseke K'amaho Ro, which translates from Kinyaranda as "Let's Hold On to Each Other."

OPPOSITE
Pascasie's kitchen.

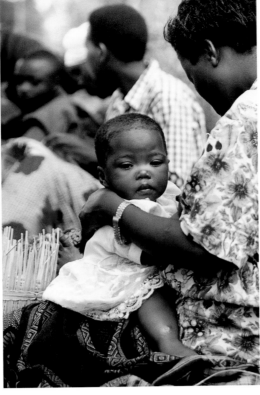
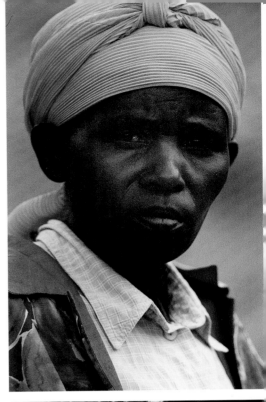

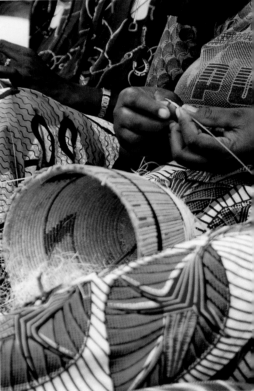

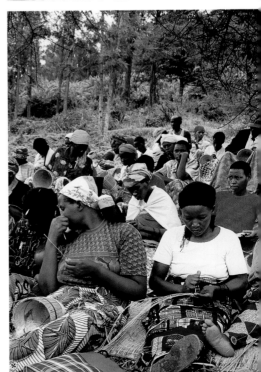

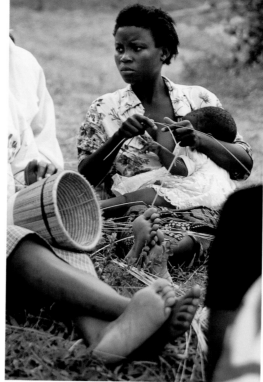

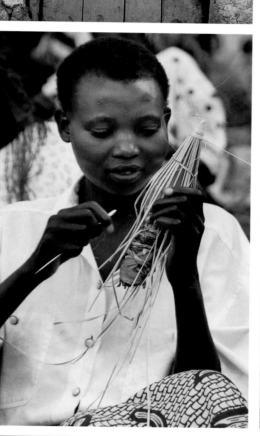

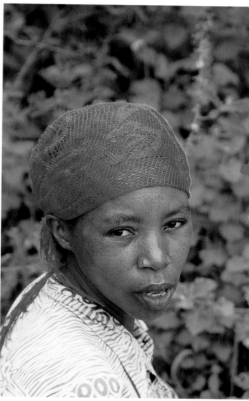
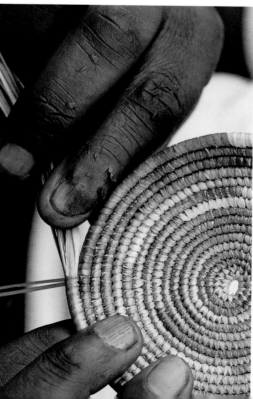
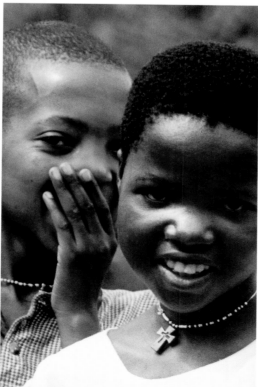

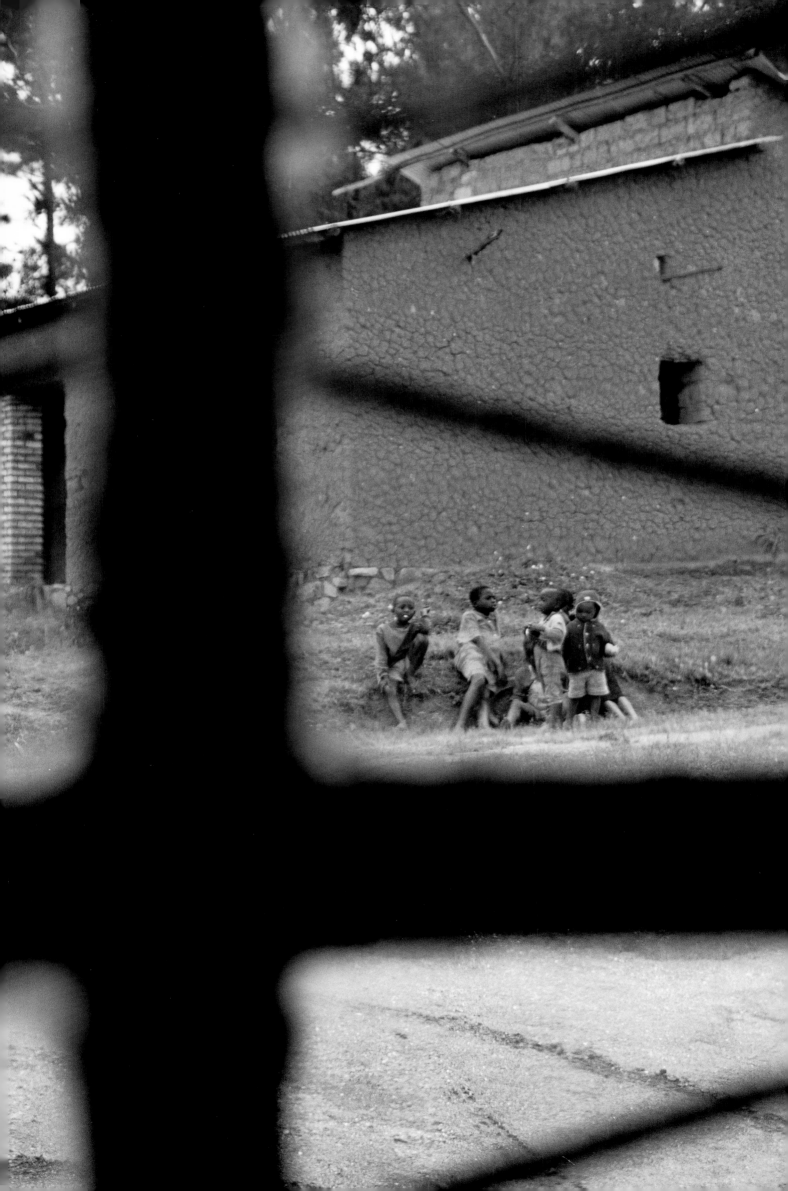

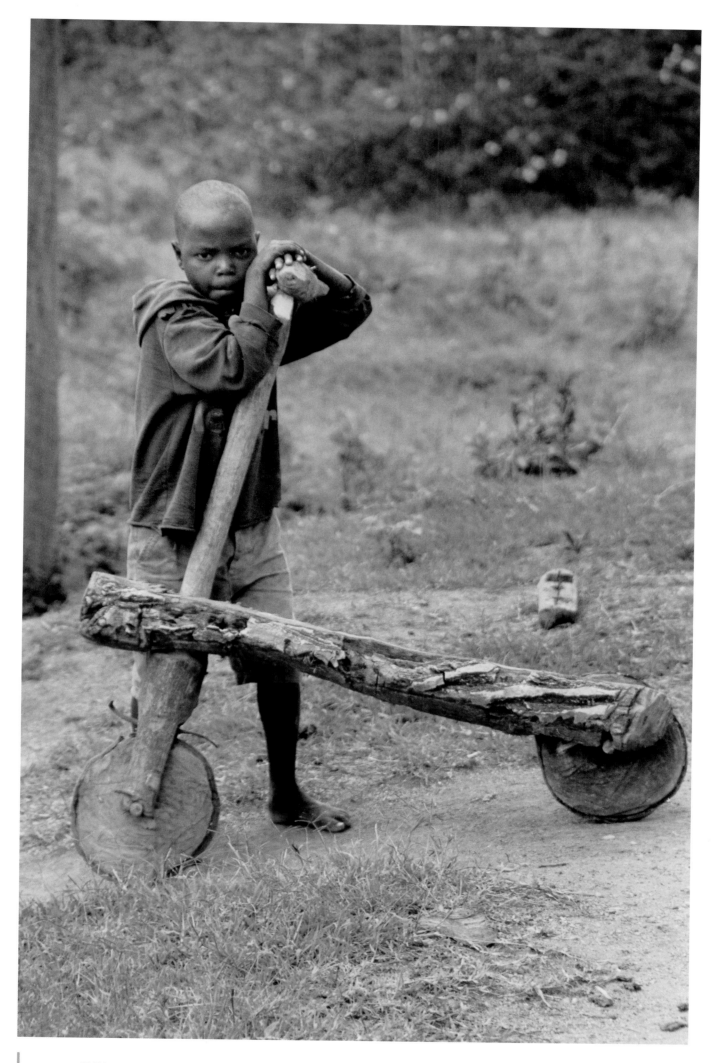

OPPOSITE **Children at play in the countryside.**
THIS PAGE **A homemade scooter.**

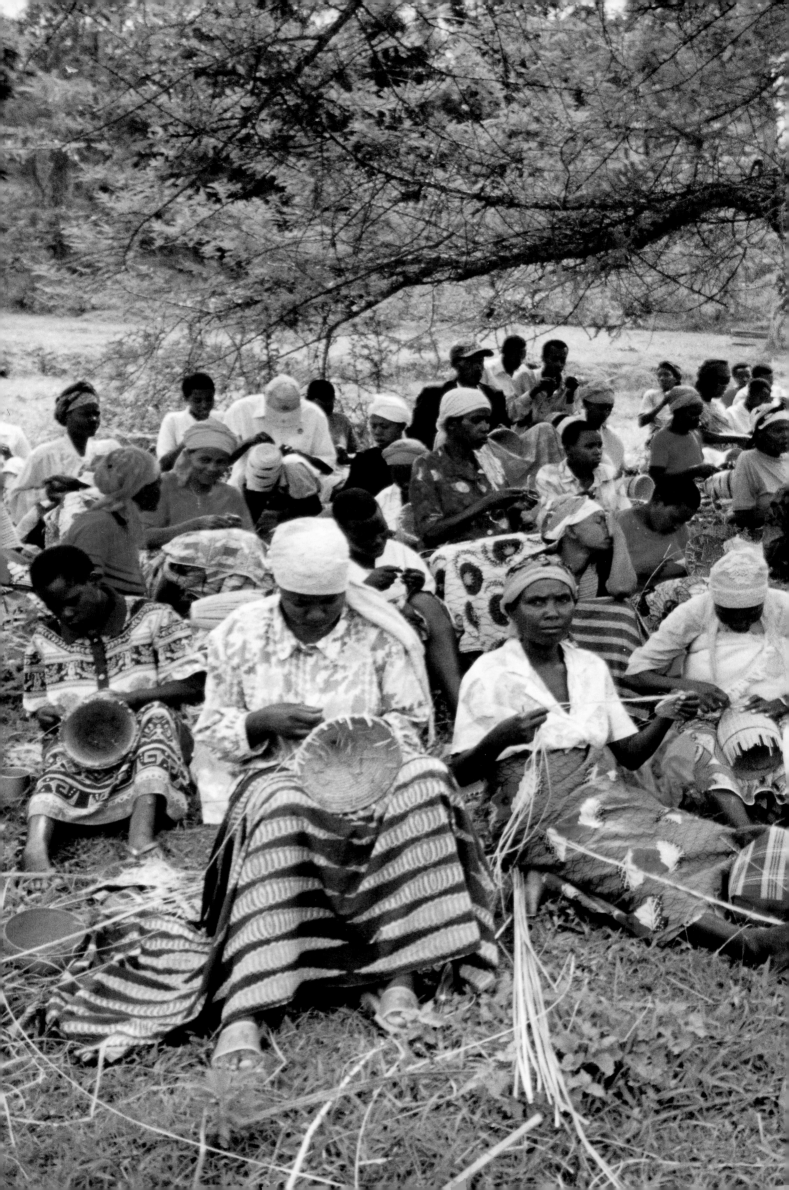

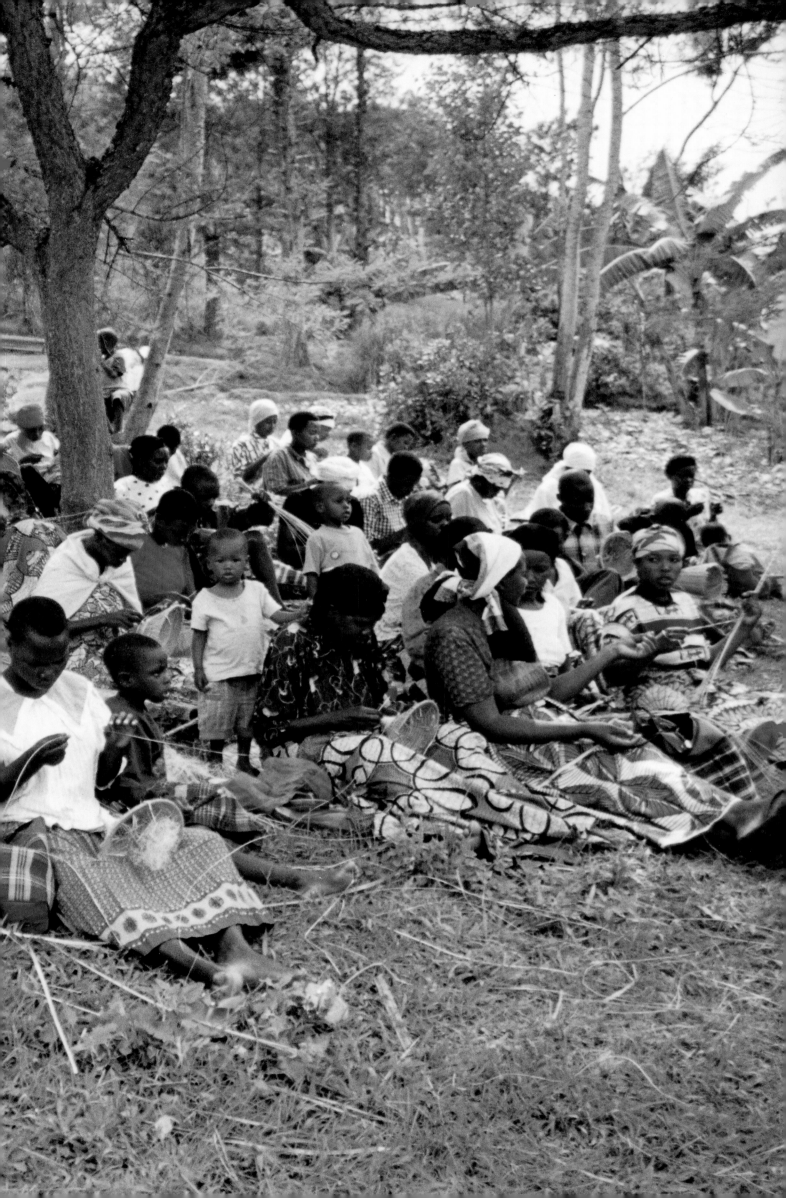

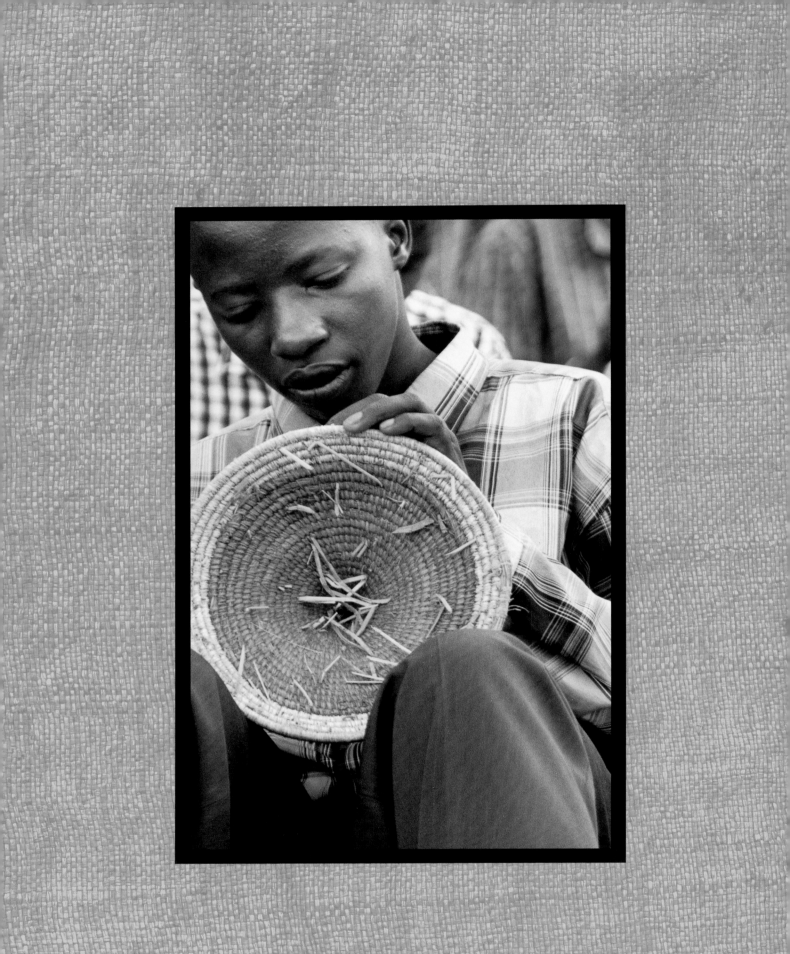

When we sit together weaving like this, we forget our differences

As prisoners convicted of genocide crimes who had served their sentences began returning to their villages, Pascasie extended invitations to them to join the collective as well. That alone was a potent act of generosity and forgiveness, but she took it one step further. Knowing that most prisoners had no way to support their families, she offered to pick up baskets from those who were still incarcerated and sell them at the marketplace. She insists, and has always insisted, that the collective is open to everyone. "Rwandans don't need anything in our lives that will divide us further," she says. "What we need are opportunities to come together."

Twice a week, members congregate under a eucalyptus tree in the bucolic village of Kirubura. They come from villages as far as fifteen kilometers away, a three-hour walk. They sit together in harmonious silence, Hutus and Tutsis side by side: stripping filaments of papyrus leaves into thread, coiling them around a model basket, and weaving the delicate thread with long silver needles. Every member of the collective was affected by the genocide. Some were perpetrators, others, victims who still bear the jagged scars of machete wounds. They all know that it is entirely possible that the man in the mustard-yellow shirt who was released from prison last week murdered the husband of the woman beside him. Specifics are rarely discussed, but spending so many hours together, working toward a common goal, has allowed the two sides to open up to one another. "When we sit together weaving like this, we forget our differences," says Pascasie. "Over the years, we have begun to change our ideas about each other."

The morning that Pascasie brings us to visit the collective, a short, sinewy forty-seven-year-old man in a lime-green tank top stands up and asks to speak. Samuel Bucyana is his name, and the previous month he was released from prison. He wants to testify, to tell everyone what Pascasie has done for him. When he got out of prison, he was destitute. He had no home, no way to support his wife and three children. Pascasie helped him find a place to live. She brought his children to the hospital when they were sick. She gave him work with the collective. "Pascasie is more than the organizer of this collective," he says. "She is like a mother to us all. She is helping me to find my way back into society, helping me to feel human again."

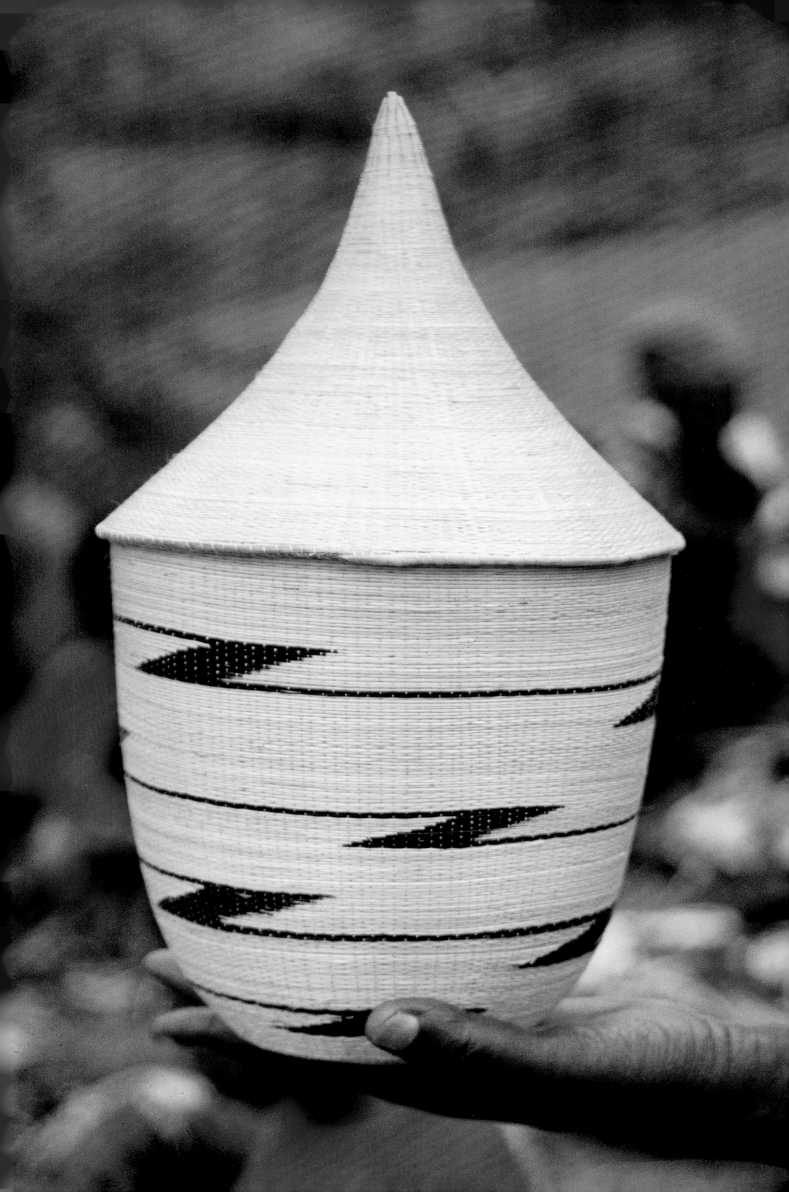

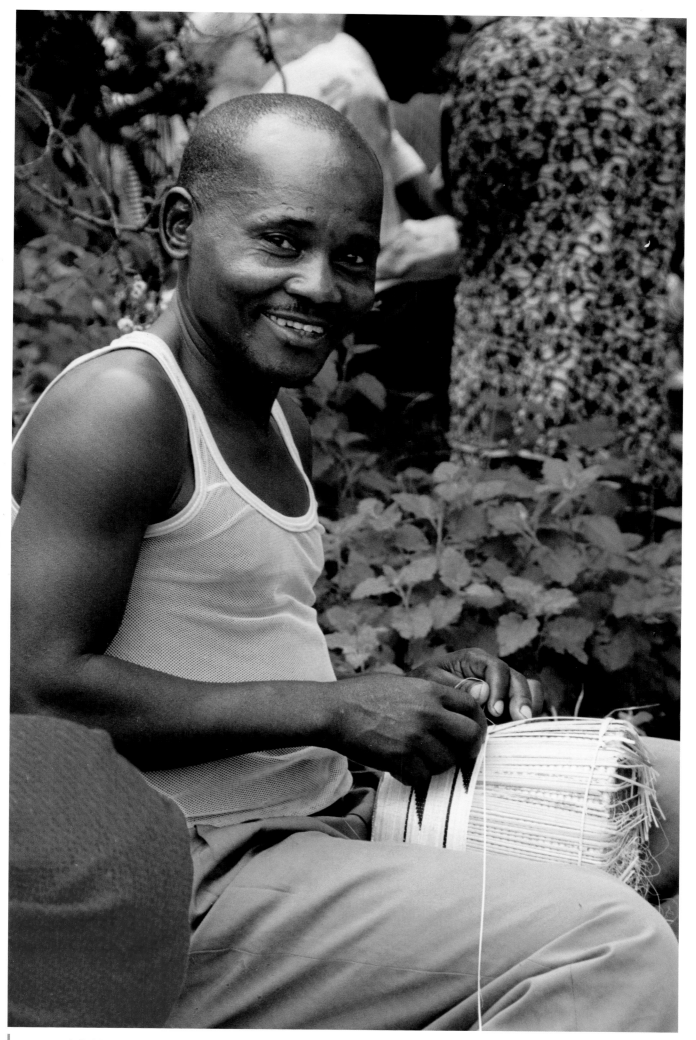

OPPOSITE **A finished basket.**
THIS PAGE Samuel, a recently released prisoner of genocide crimes.
OVERLEAF Pascasie at home recounting her experience of the genocide.

What good does revenge do me?
What good does it do anyone?
It doesn't help us to heal.

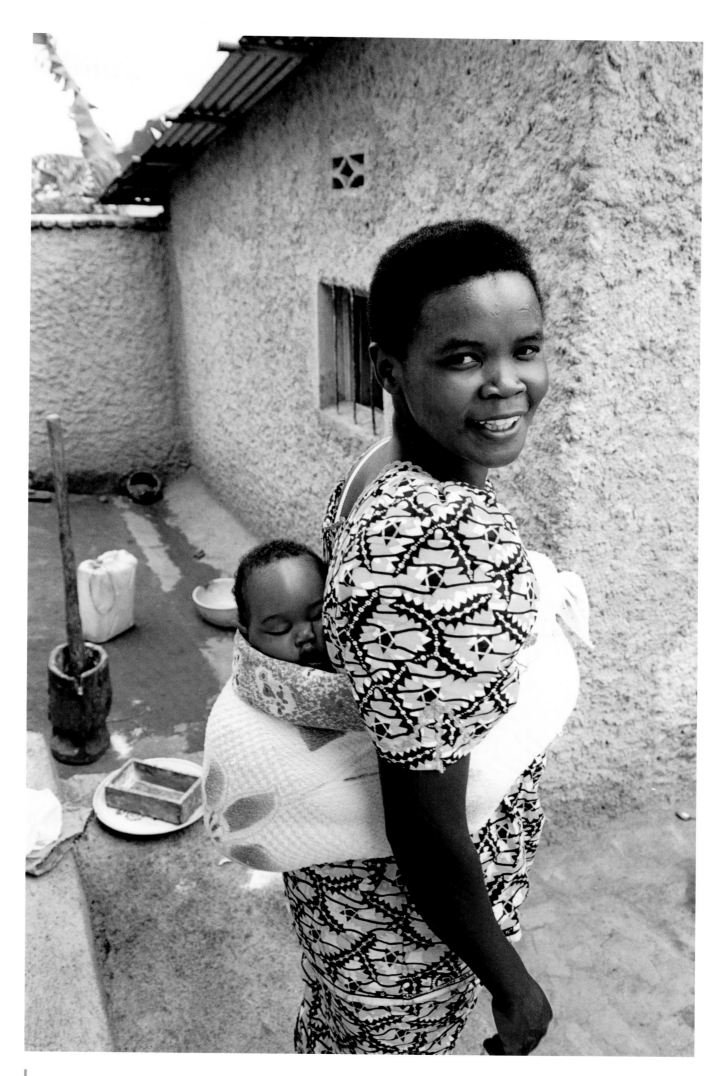

THIS PAGE **One of several women taken in by Pascasie after losing her family in the genocide.**

Almost five years after the genocide, Pascasie was talking to one of the members of the association, a twenty-seven-year-old man named Antoine, about the necessity of putting the past behind them. The man said that he would not be able to move on until he confessed something to her. Then he told her that he had killed one of her sons. "It was like Satan was commanding me to it," he said, weeping as he recounted the details: how he and a gang of men had stormed her son's house; how Pascasie's son and eight other relatives, including his two children, had cowered in the corners of the house, behind the furniture, pleading for mercy; how the gang had attacked all nine with machetes, and left them to bleed to death. And how they had returned the next day to dispose of the bodies.

The confession shocked Pascasie. For a few minutes, she was speechless. "I know that your sons are soldiers," the man said quietly. "Please, if you want to tell them to come and kill me, I understand."

Every day, perpetrators of the massacre were being handed over to government authorities by members of their community who witnessed their murderous rampages, and brought before truth and reconciliation committees that sentenced them to long prison terms. But Pascasie didn't want to turn Antoine in. She understood that he was ashamed and deeply contrite. For her, his confession was punishment enough. "When I realized how much pain he was in, I forgave him from the bottom of my heart," she says. "What good does revenge do me? What good does it do anyone? It doesn't help us to heal."

Pascasie's compatriots admire her power to forgive, but they don't always understand her. "What Pascasie does is incredibly difficult," says Aurea Kayiganwa, the president of Avega, an association of genocide widows that facilitates basket sales abroad. "Imagine spending the day with someone who killed your family. Not only spending the day with them, but actively helping them to make their lives better. Some people think she's crazy."

Lecturing the collective on a hazy morning in November, leaning into her cane, Pascasie has the air of a prophet with a staff. She is telling them not to be ashamed of their past, telling them that they are all one people now. Like all visionaries, she has long been willing to say things that people are not ready to hear. "Eight years ago, no one believed that I could get Tutsis and Hutus to work together. Now dozens of people walk many hours to get here every week. They don't just come here to weave baskets. They come because they need to feel unified again, and that is what is happening here. We are becoming one people again. We are moving on."

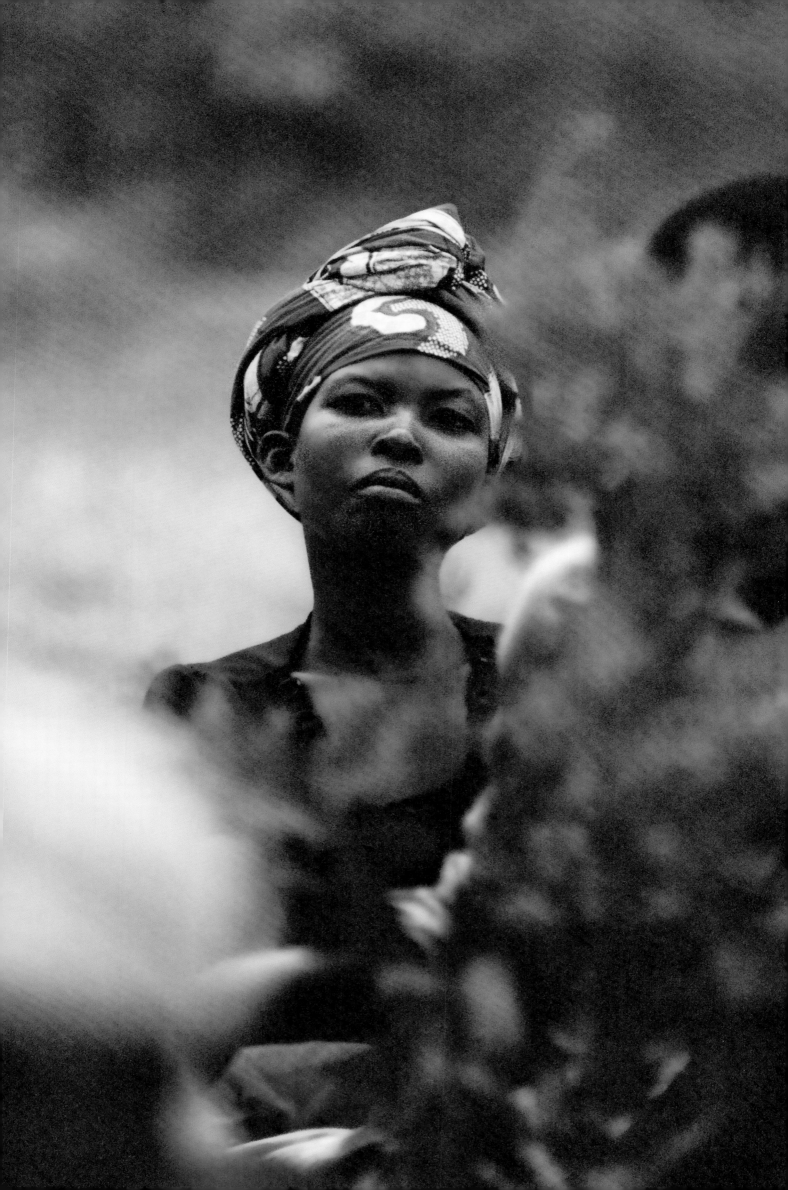

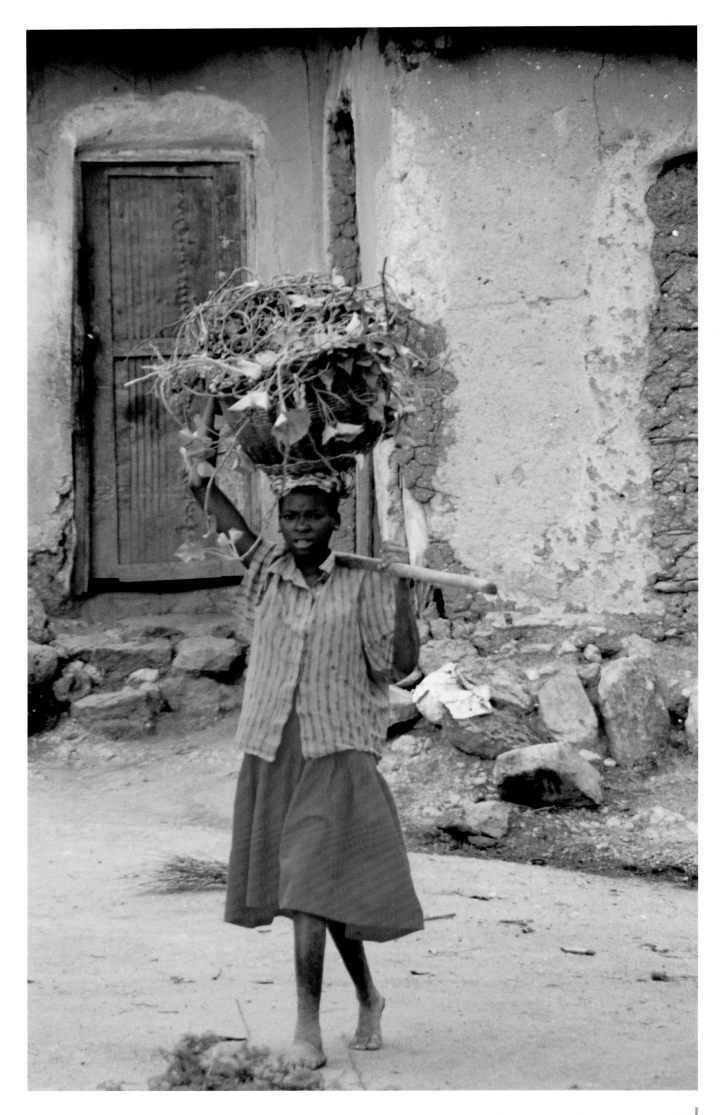

THIS PAGE **A woman carrying greens for a meal.**
OPPOSITE **A Rwandan woman and her baby.**

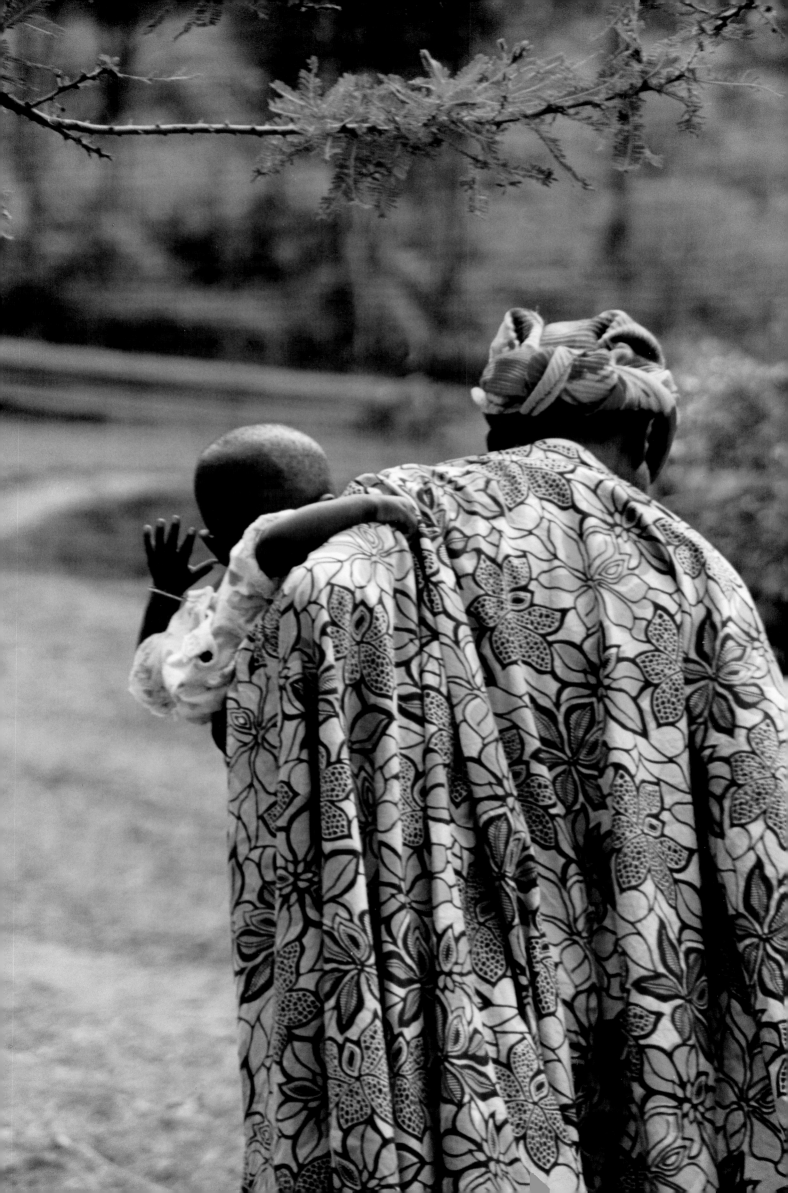

South Africa, an enormous interior plateau surrounded by rugged hills and narrow coastal plains, is located at the southern tip of the African continent.

Before the Dutch settled in the region in 1652, it was populated solely by Zulu, Xhosa, San, Khoi, and other native peoples. British colonization in 1806 and the discovery of diamonds and gold resulted in conflict between the two groups of invaders, and a series of battles, ending with the Boer War in 1902 and a defeat for the Dutch, resulted in the creation of the Union of South Africa. After World War II, the minority whites instigated apartheid, a system of harsh laws that segregated the country along racial lines.

Apartheid was abolished in 1990, after great resistance by the African National Congress and many others, including the beloved Nelson Mandela, who was elected the first black president of the republic of South Africa in 1994.

CURRENT SITUATION:

South Africa is the most ethnically diverse country on the continent, and is home to more whites than any other nation in Africa. Eight official and eleven unofficial languages are spoken by the people.

The present population is 44,187,637, a figure that takes into account the extreme mortality rate due to AIDS. Unemployment in 2005 was at 25.2%, with 50% of the population living below the poverty line as of 2000. President Thabo Mbeki and his government are now focused on targeting inflation and liberalizing trade as a means to bolster South Africa's growing economy, and 2006 was named the Year of Accelerated HIV Prevention by the member states of the Africa Region of the World Health Organization (WHO).

AIDS ORPHANS
SOUTH AFRICA
PRUDENCE MWANDLA

n 1993, Prudence Mwandla's husband was shot and killed in an armed robbery at one of the two grocery stores he owned in downtown Durban, South Africa. Prudence barely left the house that year. She barely left the house the next year, either, and by then her friends and her two grown children had become very worried about her. One afternoon her pastor stopped by to visit.

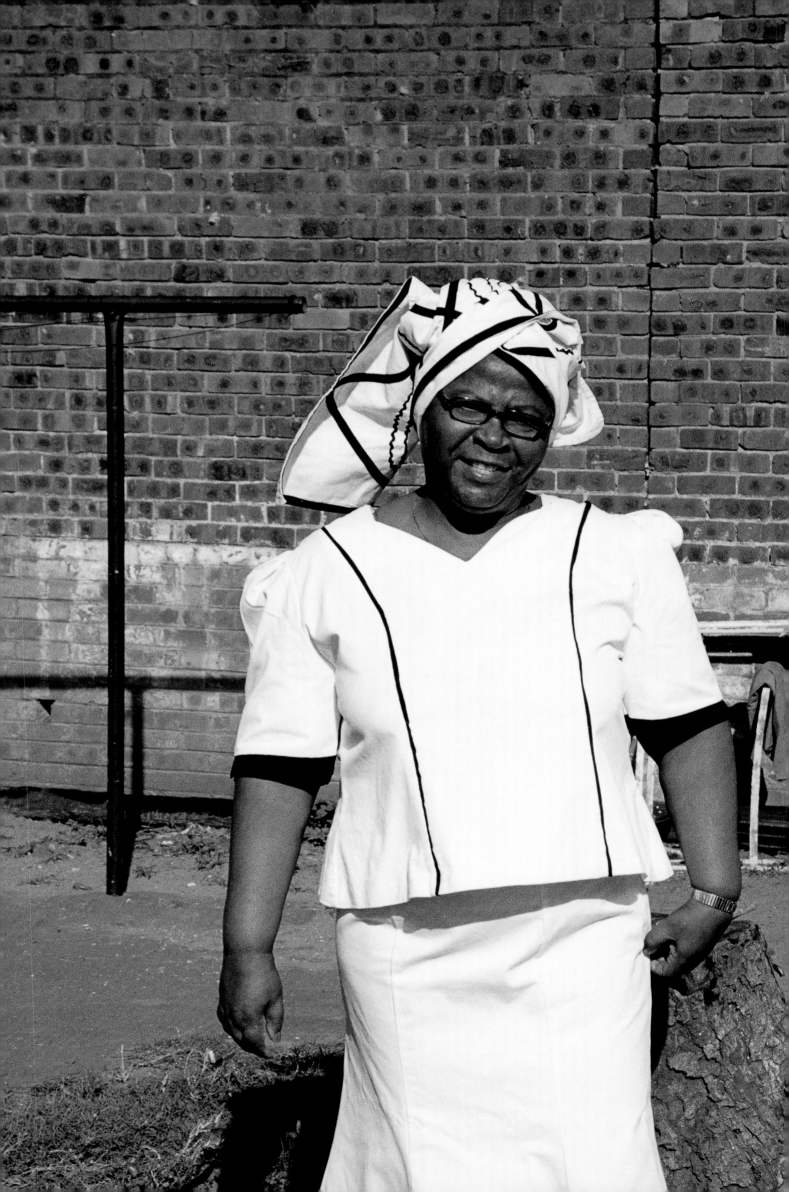

I knew right then what I wanted to do with my life.

OPPOSITE
Prudence Mwandla at the orphanage.
THIS PAGE
Kids wrestling at the orphanage.

"He said to me, 'Come on, Prudence!'" she recalls. "'You can't go on this way. Come out for a drive with me. You have to start living again.'" He hustled her into his car and took her on a ride around downtown Durban. They had been driving for about half an hour when Prudence saw a young child, about four or five years old, get hit by a car. He died on the spot. His mother had been selling fruit at the side of the road, and she was too preoccupied to keep an eye on him. "I knew right then what I wanted to do with my life," she says.

The next day she and the pastor went for a ride again, and this time, Prudence stopped whenever she saw a woman vendor with a child. "I told the women that if she would bring her children to me in the morning, I would watch them until the end of the day for no charge," she says. At the time, Prudence had no place to care for the children, but she had faith that she would find one. That same afternoon, she rented two small rooms at the YMCA for forty dollars a month. A few days later, she was babysitting twenty children, from three-week-old infants to six-year-old toddlers.

After almost a year of caring for the children of working single mothers, Prudence began to notice that a few of the children were not picked up at the end of the day. They would slink out on their own, and return the next day in the same clothes, a shade dirtier. "I would ask them, 'Where is your mother?', and for a while they made up excuses, but eventually it came out that their mothers had died and they were orphans, deposited at the shelter by relatives who could not afford to care for them."

It was not until the late 1990s, however, that it became clear to Prudence that these children were AIDS orphans. Until then, most AIDS-related deaths had been misclassified as deaths resulting from TB or pneumonia, with no mention of HIV as the underlying cause. But as the number of AIDS-related deaths began to skyrocket, and the severity of the epidemic in South Africa was finally acknowledged, it became painfully clear that AIDS was leaving in its wake a generation of parentless children.

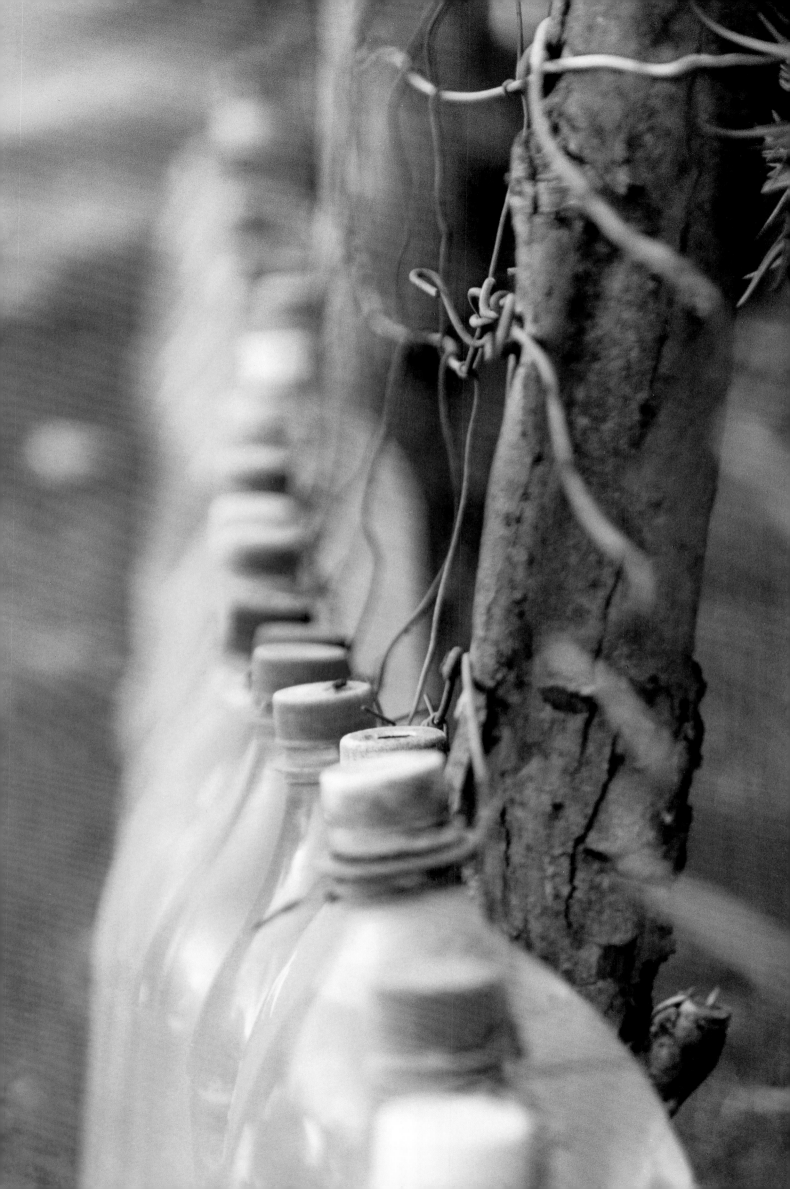

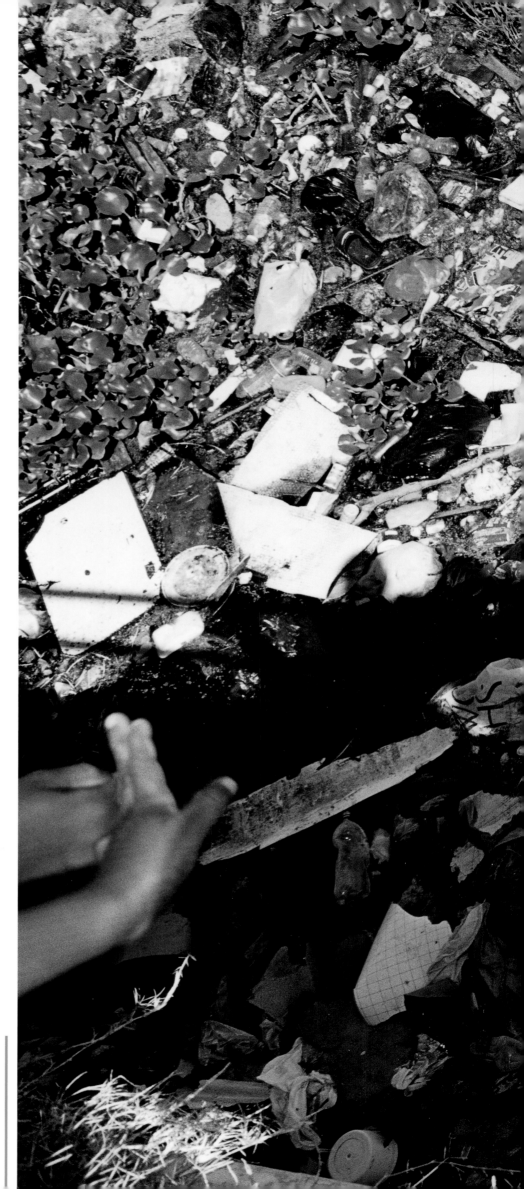

PRECEDING
A plastic-bottle fence.
THIS PAGE
**Shadows of children leaning
over a garbage-filled river.**

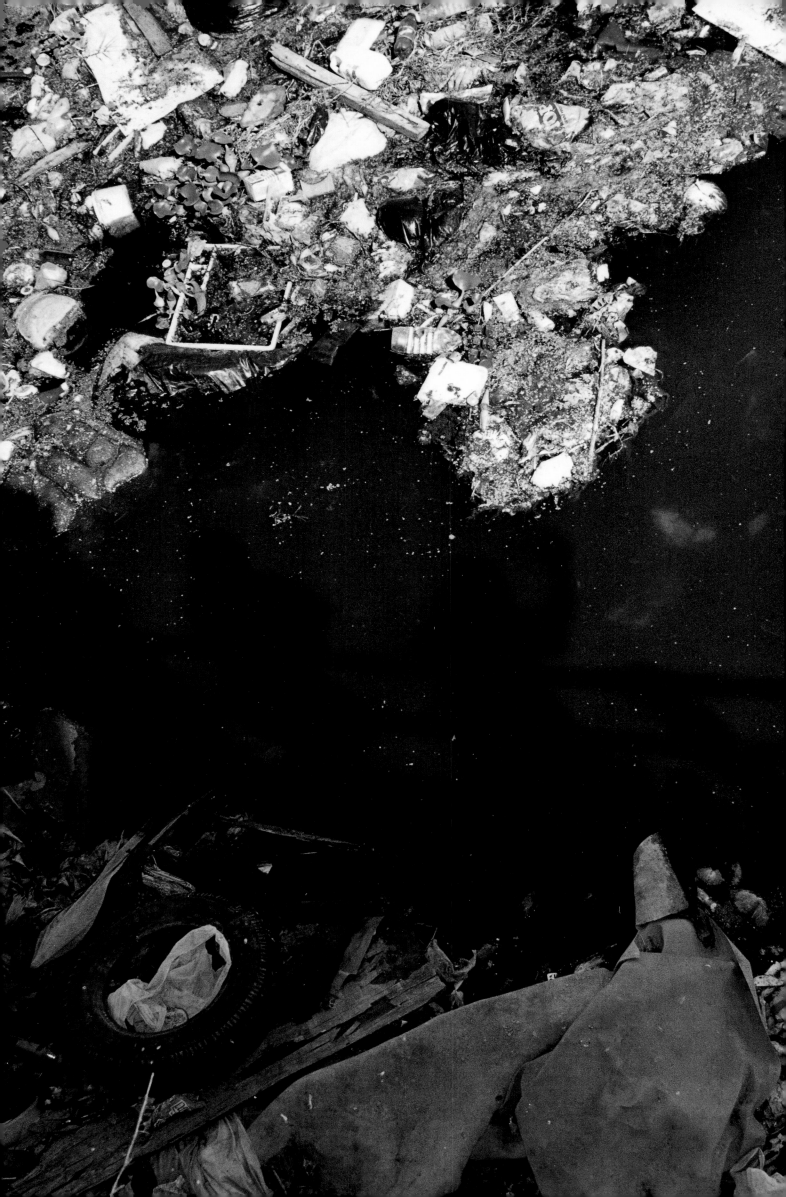

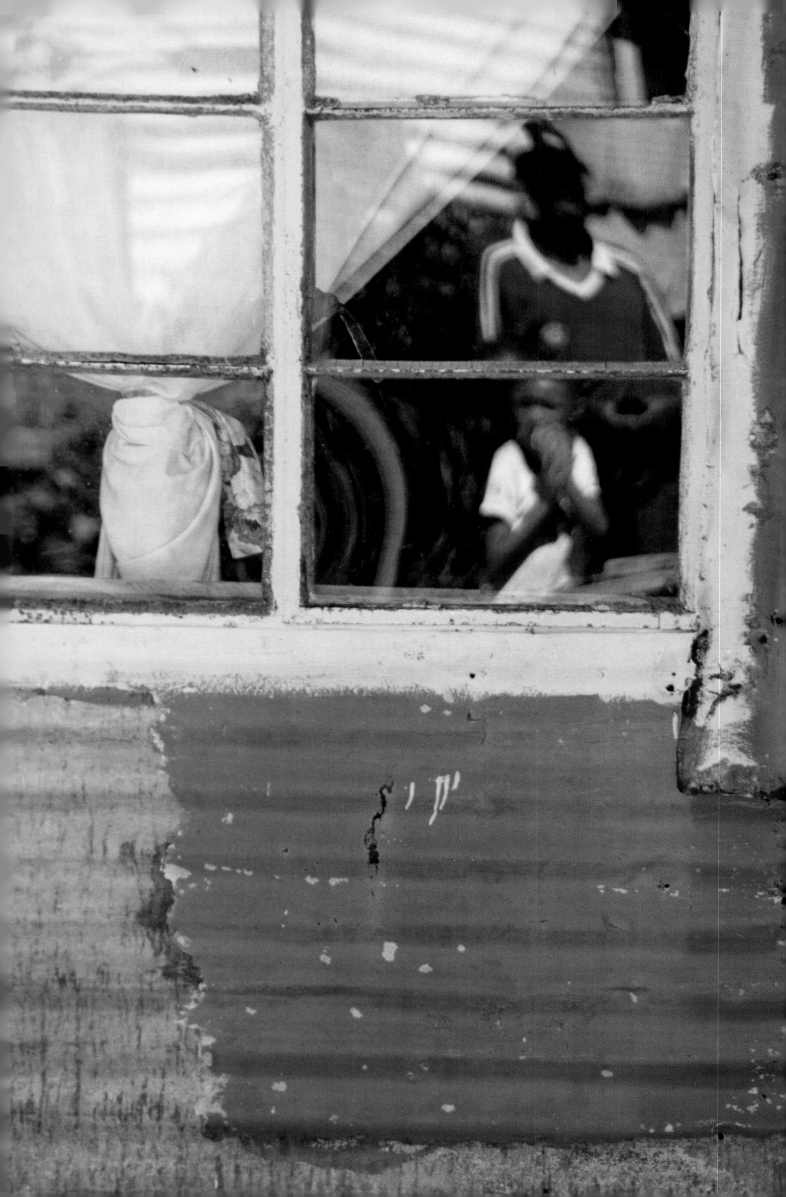

OPPOSITE
Reflection in a window
in one of South Africa's
townships.
THIS PAGE
TOP The orphanage.
BOTTOM A little girl in
Capetown.
OVERLEAF
Kids at the orphanage.

123

By the year 2000, Prudence's flock of young charges had quadrupled, and she had taken in several orphans. So she migrated from the dingy rooms she had been renting for her day-care center to a three-bedroom house in a suburb of Durban. She had been there for two years, caring for eighty children, when the government threatened to repossess the house. It turned out that the owner, who had rented it to Prudence for a discount, had never fully paid for the house. One of the Durban newspapers ran an article about the impending crisis, and among the offers of charity that poured in was a house. It was on the market for $62,000, but the owners wanted to sell it to Prudence for $12,000. By that time, Prudence had burned through most of her savings, but three companies offered to donate the money, and in late 2002, Prudence and her charges moved in to a sunny, yellow five-bedroom house with a swimming pool.

Because Prudence had started her shelter so informally, she had a patchwork of abused children, malnourished infants, and teenagers orphaned by AIDS. Durban's Department of Welfare requires that children be segregated by age group and need, so they asked Prudence which population she most wanted to serve. Acutely aware of the AIDS orphan crisis by this time, Prudence decided to focus on children ages 8-17 who have lost their parents to AIDS. The shelter was christened Khulani Children's Home and AIDS orphanage. Khulani is a Zulu word meaning, "we all grow up together." It is funded primarily by Michelle Footwear, a Durban shoe manufacturer, which pays the utility bills, the school fees and uniforms, and the salaries for the staff: two child care workers, a cook, a cleaning woman, and a part-time social worker.

Some of the children at the shelter have lost both parents to AIDS. Others have lost only their mothers, but have absentee fathers. Four of the children are HIV positive themselves. The traditional African ethos is for extended families or neighbors to absorb orphaned children into their households, but the AIDS epidemic is generating orphans so quickly that many families are unable to care for all of their orphaned relatives. There are 1,100,000 AIDS orphans in South Africa alone—the second-highest number on the continent. In 2004, almost thirty percent of the population in South Africa was living with HIV or AIDS. KwaZulu-Natal, the province where Durban is located, has the highest infection rate in the country—forty percent. Some families, already financially overextended, simply do not have the resources to take in more children. Others do not want the offspring of AIDS patients living with them because they naïvely fear that they will contract the disease. Ignorance about how HIV is transmitted is still a serious issue in South Africa and throughout sub-Saharan Africa.

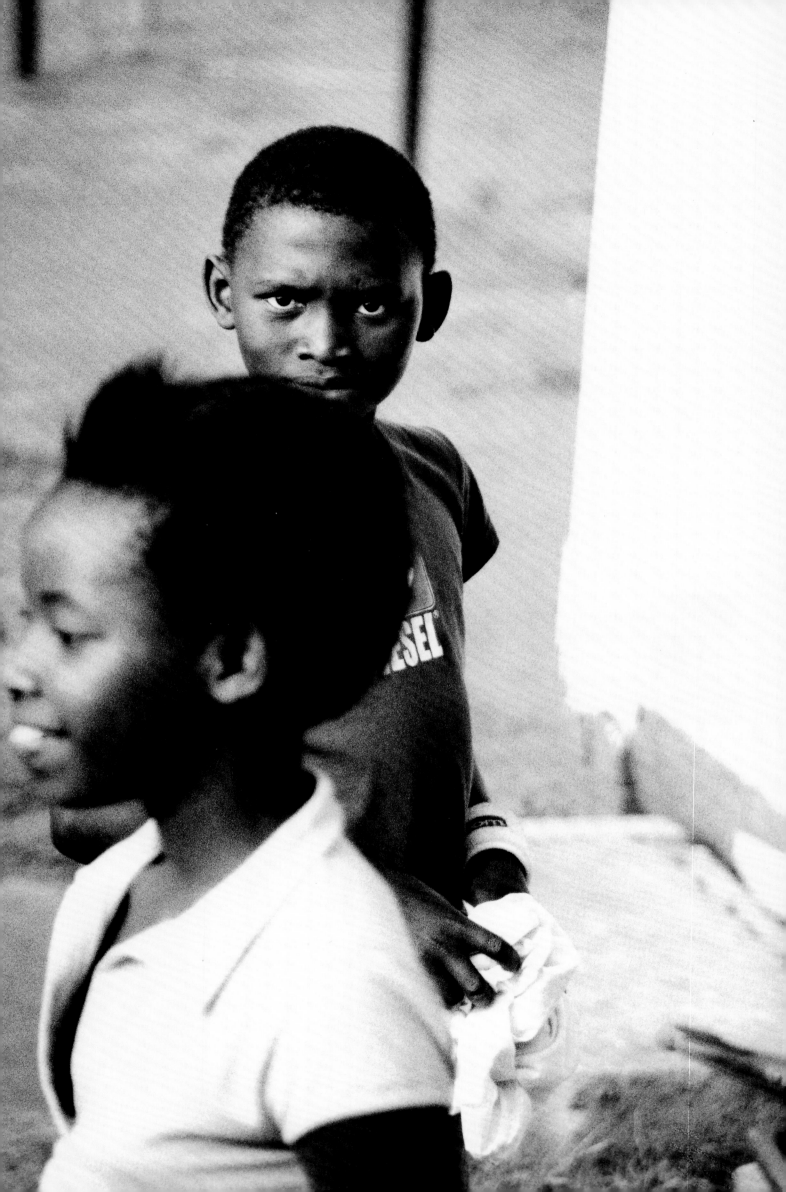

These kids are like my own children. They aren't going anywhere until I know they are going to do well out there in the world.

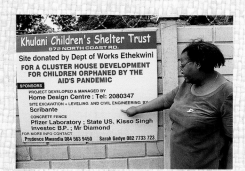

Prudence never condemns aunts or uncles or grandmothers who cannot shoulder the financial burden of orphaned nephews or grandchildren. What disturbs her are the stories of AIDS orphans who are treated as pariahs by their own relatives. She nods in the direction of thirteen-year-old twin brothers who are engaged in a fierce game of soccer in the yard. After their mother died of AIDS two years ago, they went to live with their grandmother. "She didn't want them and she let them know it," says Prudence. "She would feed them porridge while she sat at the table with them eating meat." Even when her daughter was frail and bedridden, the grandmother used to scold her for her illness. "She blamed her for having AIDS," says Prudence. "She attributed it to promiscuity." Eventually, she kicked her grandsons out of her house. They were living on the street when a friend of their mother's brought them to Khulani.

Prudence is a forty-eight-year old, stout, determined woman in wire-rimmed glasses and practical black pumps. She is kind but not effusive, driven but not quite aggressive. She does not raise her voice or lose her temper. She merely says what needs to be said and asks for what needs to be asked for, and she does it until she gets results. In this way, she has been able to find companies and individuals to donate food, clothing, and furniture to the orphanage, and she has secured a parcel of land from the government, where she plans to expand the orphanage. Every Monday afternoon, Prudence pulls up to the loading dock of a high-end supermarket chain, where she fills the trunk of her car with fancy provisions that have just barely passed their suggested sale date: mixed herb salad, Italian bread, organic yogurt, chicken breasts, gourmet potato chips, and firm, plump nectarines. On Tuesdays, she is sent rice and toilet paper from a paper goods company; and on Wednesdays, she picks up cartons of vegetables from a third donor.

OPPOSITE
A barbed fence.
THIS PAGE
TOP **Prudence at the site of the new orphanage.**
BOTTOM **One of the teenage orphans with food donations.**

OPPOSITE **South African township.**
THIS PAGE **Durban, South Africa.**
OVERLEAF **Headstands at Khulani Children's Shelter.**

Sweepers Boys

Mon: Ayanda

Tues: Maxwell / Paul

Wed: Njabulo

Thur: Sandile

Fri: Mthokozisi

Occupancy codes dictate that Prudence can house only thirteen children at her current site—just a fraction of the hundreds of AIDS orphans in KwaZulu-Natal province. With that unmet need in mind, Prudence doggedly pursued a meeting with officials at the Department of Works last year in order to apply for a building site for a larger facility. It took her six visits and countless hours of flipping through outdated waiting-room magazines to get a meeting with the right official. Three months later, she was granted a building site and $200,000 for construction materials to build a cluster-house orphanage of six buildings that will house five children each.

The schedule at Khulani is regimented and the rules are strict. A color-coded schedule hanging on the wall in the foyer outlines the children's regimen. The children are woken at 5:30 AM so that they can bathe before school. The girls put on their starched gingham dresses, the boys their white dress shirts. They prepare their own breakfast, and they do their chores. Then Thabisile, one of two caregivers, inspects first the girls bunk, then the boys, then their lockers. Everyone is expected to keep their things in order at all times.

After school, the children are required to go straight home. There is no going out for ice cream or playing soccer with their friends. Back at Khulani, the tight schedule picks up again. The children eat lunch from 3 to 4, they wash their uniforms from 4 to 4:30, they do their homework from 4:30 to 6, and they have dinner from 6 to 7. Finally, at 7:30, they are allowed one half hour of television, usually the news. By 8 PM, they are in bed.

Everyone here has been through the same thing, so we understand one another.

Mixing boys and girls is not ideal. They are, after all, teenagers, with teenage hormones and teenage bodies and curious teenage thoughts. To prevent romantic liaisons, there is a rule that girls and boys are to play separately. They can do homework in the same room, but they are not allowed to romp around in the yard together, for example. Theoretically, at least. On the day that I visited, all thirteen kids were doing just that with their new puppy, a sandy-colored mutt whose name was still being disputed. The dilemma will be solved next year, when construction on the new facility is slated for completion. Boys will be housed in the current location, and the new orphanage will be reserved for girls.

PRECEDING
Inside Khulani Children's Shelter.
THIS PAGE
TOP **Doing laundry at the orphanage.**
BOTTOM **Free time at the orphanage.**
OPPOSITE
**Kids at Khulani bond easily because they
have been through similar traumas.**

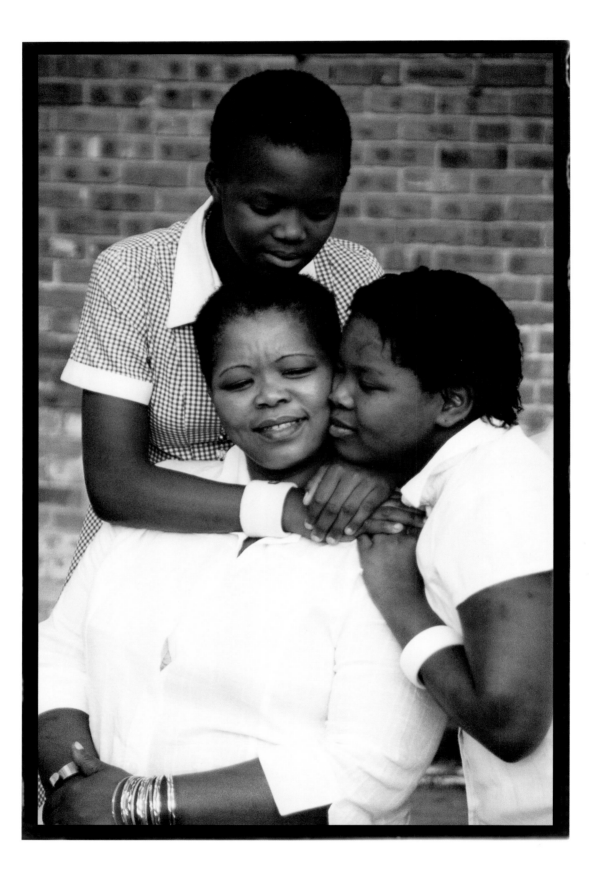

Because AIDS is still so stigmatized in South Africa, many of the children at Khulani will tell you their parents died of TB or pneumonia. Some know the truth and prefer to keep it a secret. Others do not know, perhaps because they would rather not.

Yet despite the trauma of having lost their parents, the children at Khulani seem happy and well-adjusted. It helps that there is a social worker on staff who counsels them through their grief. Perhaps more importantly, the kids have each other. "The other girls here are like my sisters," says Mbeli Khanyase, a sassy, outspoken twelve-year-old who is braver and more articulate than her years. "We can't open up to our friends at school about our parents, because the first thing people assume is that you are HIV-positive, too. But everyone here has been through the same thing, so we understand one another."

Mbeli's mother is still alive, but her health is tenuous. She has been HIV-positive for seven years, and she has a chronic case of meningitis. Her doctor says that it is a miracle that she is still alive. Most of the children at Khulani are orphans, but when Mbeli's mother became gravely ill three years ago, she begged Prudence to take her children in. Her husband died eight years ago, and she was too sick to care for them on her own.

I know my mother brought me here for the right reasons ... she wanted to know that I would be cared for when she dies.

When Mbeli's mother first brought her and her fifteen-year-old sister, Choice, to Khulani, Mbeli was hurt and angry. "I was very impudent," she says. "I didn't want to live with all these other children. I wanted to live in my own house, with my own mother." Now, however, Prudence is like a second mother to her, and Khulani feels like home. "I know my mother brought me here for the right reasons," she says. "She knew she didn't have much longer to live, and she wanted to know that I would be cared for when she dies."

Government regulations dictate that children must leave Khulani when they turn eighteen, but Prudence says she will not turn any child out without making sure that they are on solid footing. She plans to enroll some of the children in college, while others will have the option of working for one of the three companies that help fund the orphanage. "These kids are like my own children," says Prudence. "They aren't going anywhere until I know they are going to do well out there in the world."

HISTORY OF REGION:

Africa's most westerly country, Senegal is a land of rolling, sandy plains that rise to foothills in the moist, tropical southeast.

During the eighth century, part of Senegal was ruled by Ghana. The rest of the country came under the Tekrour Empire in the ninth century. As the two realms weakened in the thirteenth and fourteenth centuries, the Djolof kingdom fell into power. The Europeans arrived in the 1400s, with France ultimately taking possession of the region. Gorée Island became a key hub for the Atlantic slave trade, and millions of Africans were sent to the Americas from this point.

Senegal joined the French Sudan to form the Mali Federation in 1958, and independence from France was gained on April 4, 1960. The Federation dissolved later that year, and Léopold Senghor became Senegal's first president in August of 1960. An advocate of "African socialism," Senghor retired in 1981, handing power to his protégé, Abdou Diouf, who lead Senegal for the next 20 years.

CURRENT SITUATION:

There are 11,987,121 Senegalese in the country today, 43.3% of whom are Wolof in ethnicity. French is Senegal's official language, and 94% of the people are Muslim.

Known to be a model African democracy, Senegal has one of the more stable economies in the region despite extensive poverty and a 48% unemployment rate. Current president Abdoulaye Wade, founder of the Senegalese Democratic Party, has been in office since March of 2000. In January 2001 a new constitution was voted in that legalized opposition parties and granted women equal property rights with men. In spite of attempts at making peace, Senegal continues to be challenged by a southern separatist group in the Casamance region that has been fighting with government forces since 1982.

POVERTY
SENEGAL

AMINATA DIEYÉ

In a sandy-floored four-by-six-foot workshop, unofficially patrolled by a baby goat, eighteen-year-old Anta Ndaye is learning to use a chop saw to cut long strips of aluminum to fit a door frame as a mentor looks on. His hand on Anta's forearm, he guides her as she raises the whirring circular blade again and again, ensuring that the cut is straight and clean. Passersby glance at her—a strikingly beautiful girl in a baggy blue uniform, baseball cap, and pink sequined shoes—with a mixture of surprise and confusion. Even in Western metropolises, it is unusual to see women metalworkers. In Senegal, a patriarchal culture where gender roles are still strictly divided, it is like seeing a fern growing in the desert.

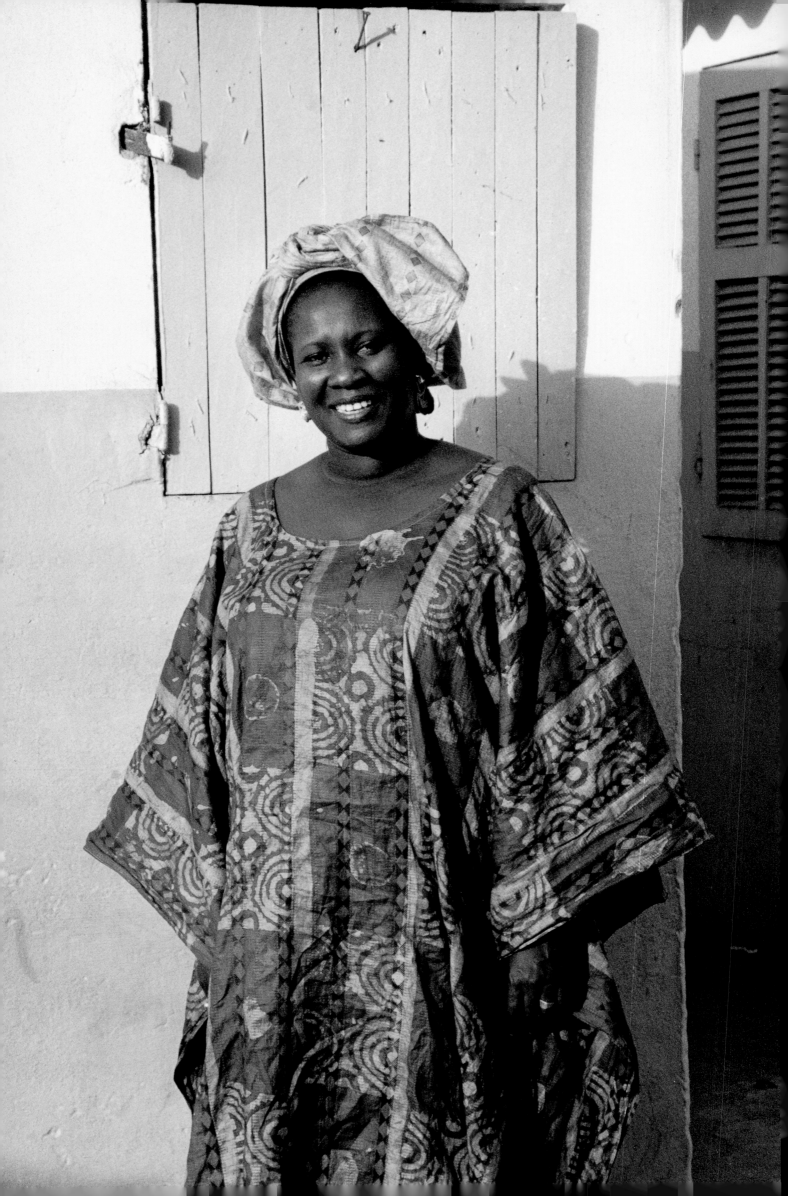

OPPOSITE
Aminata Dieyé
THIS PAGE
TOP **A bus in Dakar.**
BOTTOM **Kids at a market in Dakar.**

Technical skill is in Anta's blood: her father is an auto mechanic, and as a child, she used to hang around the local garage instead of going to school, where her classmates teased her because she started her education late in life, at age 11. "I hated going to school," says Anta. "The other kids would laugh at me because I was so much bigger, and I didn't know how to write or do math or anything." Consequently, today Anta can write little more than her name, and she can read little more than the familiar language of shop signs.

Being illiterate means that she has few employment options, and those she does have pay poverty wages. She could try to find work as a tailor or a hair stylist, but competition is fierce for both positions and customers. Many illiterate women wind up selling snacks and bottles of water at the side of the road, where they earn about twenty cents a day. For a single mother like Anta, who has an eighteen-month-old son, the earnings fall far short of a living wage. Unskilled, and anxious about making ends meet, these women often fall into informal prostitution, taking on two or three "boyfriends" who help them get by in small ways, buying them food, clothing, the occasional feminine trinket.

To forty-two-year-old Aminata Dieyé, who has been a women's rights crusader in Senegal for two decades, the solution to this cycle of poverty and sexual exploitation seemed straightforward: why not train women to do jobs that were traditionally considered male? Not only would it boost their earning potential by fifty or sixty percent; it would also open up a whole variety of unexplored opportunities. Instead of choosing between sewing and braiding hair, women would be able to work as carpenters, auto mechanics, masons, construction workers, plumbers, metalworkers. Their increased earning power would produce psychological dividends as well. "When a woman is financially independent, it gives her confidence," says Aminata. "She has more power—in her family, and in society. She is less vulnerable to exploitation, less likely to stay in an abusive relationship." In giving women access to male-dominated trades, Aminata also hopes to help women transcend cultural barriers. "I want to change the mentality of society," she says, "to show people that women can do anything that men can do."

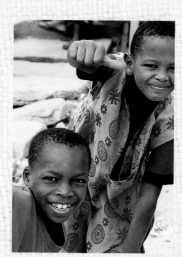

I want to...
show
people
that women
can do anything
that men
can do.

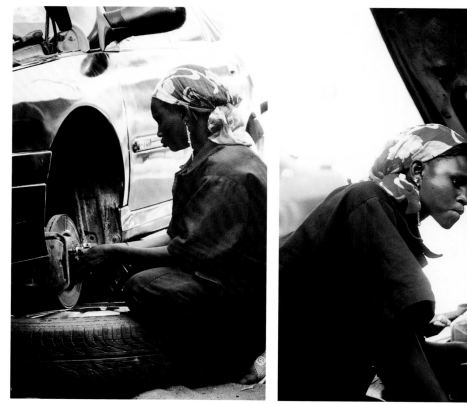

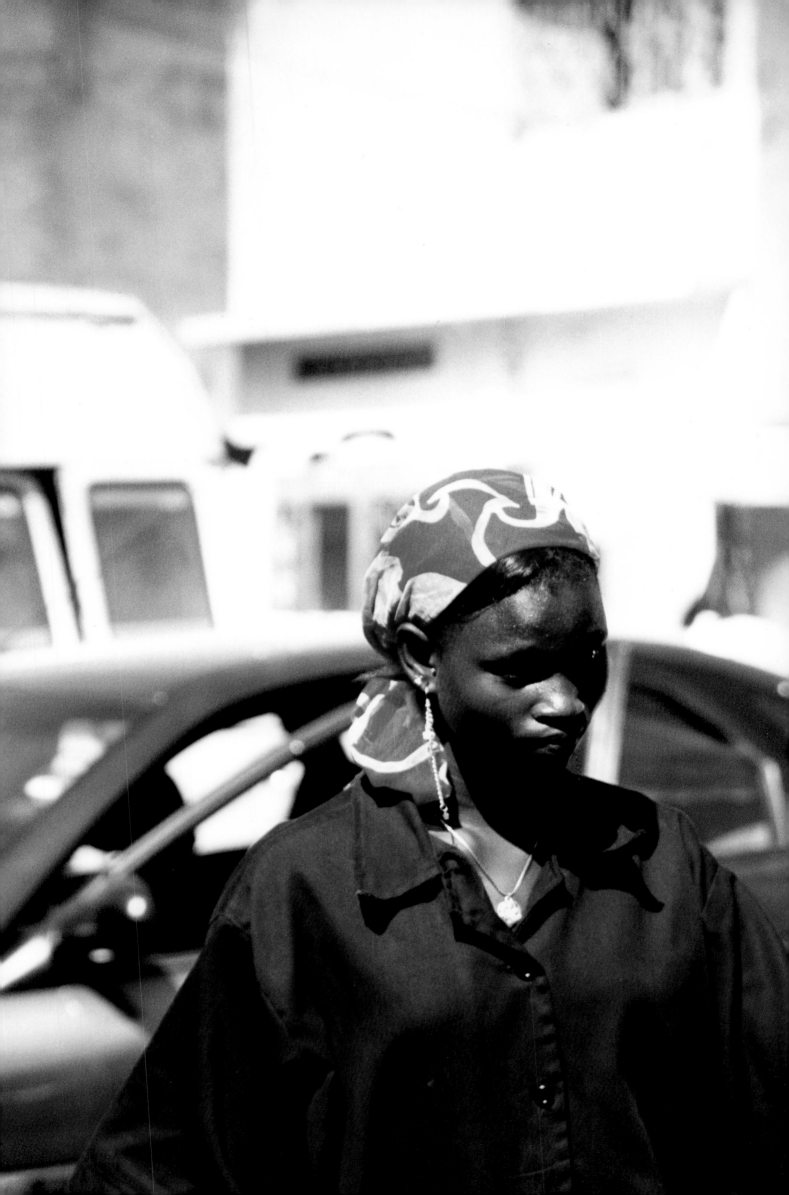

In 1999, Aminata launched a pilot program in a southern region of Senegal called Kolda, where half of the population lives below the poverty line. She wanted to see if girls would take to the idea of repairing cars and building schools—but first, she needed their parents' blessings. She anticipated obstacles: in a conservative rural area like Kolda, where repressive practices such as child marriages still occur, the idea of women working "male" jobs is downright radical.

Aminata started by visiting the parents of young women in the community, to explain the financial benefits of their daughters learning a trade, and to assuage their fears. Initially, the girls parents were resistant. Women aren't fit for these masculine jobs, they said. They are too weak, too feminine. They don't have the mental capacity . Some families refused to let their daughters participate. But those who tentatively put their daughters into Aminata's hands gradually softened as they saw the girls becoming more competent by the week—operating lathes and laying bricks and replacing brakepads.

Buoyed by the success of the pilot program, Aminata returned to Dakar, the capital of Senegal, where she started an organization called La Case des Jeunes Femmes, or "the house of young women." Under the umbrella of her new organization, she launched the training program in a neighborhood called Khar Yalla. Khar Yalla—which translates from Wolof as "waiting for God"—is a bustling quarter of tightly packed houses and fly-by-night businesses. Goats rummage through heaps of garbage piled on the curb; blankets spread on the sidewalk serve as teahouses, cobblers, novelty shops where knock off Adidas bags are sold. There is a high unemployment rate here, as well as a significant population of single mothers.

A social worker in the neighborhood helped Aminata identify young unemployed single mothers, then facilitated introductions to their families. Once again, Aminata began by visiting the girls' parents to sensitize them to the idea of their daughters defying tradition—but this time, she had evidence of her program's success, in the form of photographs and testimonials from the girls who had participated in the pilot program in Kolda.

A few weeks after her home visits, Aminata had recruited fifteen new participants to begin training. Among her crop of students are girls who want to become auto mechanics, girls who are interested in being metalworkers, and girls who want to make aluminum window frames. Three mornings a week, the girls crowd into the bamboo enclosure of a community center painted with Disney characters, where they are taught the theoretical aspects of their trade—mathematics, and how to draw up construction plans, for example—as well as learning the skills they would need to run their own small business.

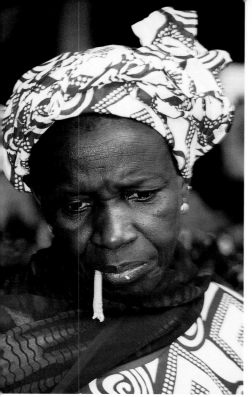

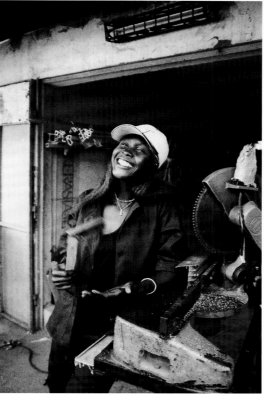

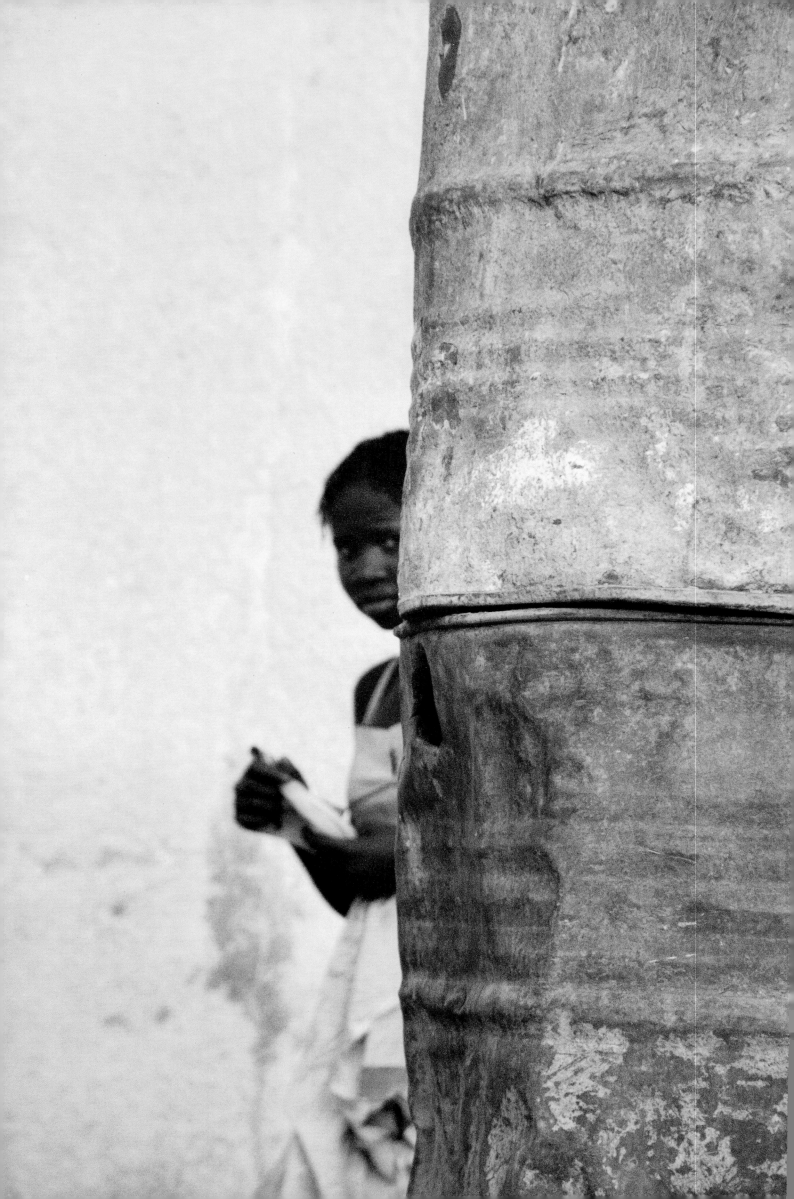

OPPOSITE
A young woman hiding behind oil drums
THIS PAGE
A barber shop in Dakar.
OVERLEAF
Île de Gorée, off the coast of Dakar.

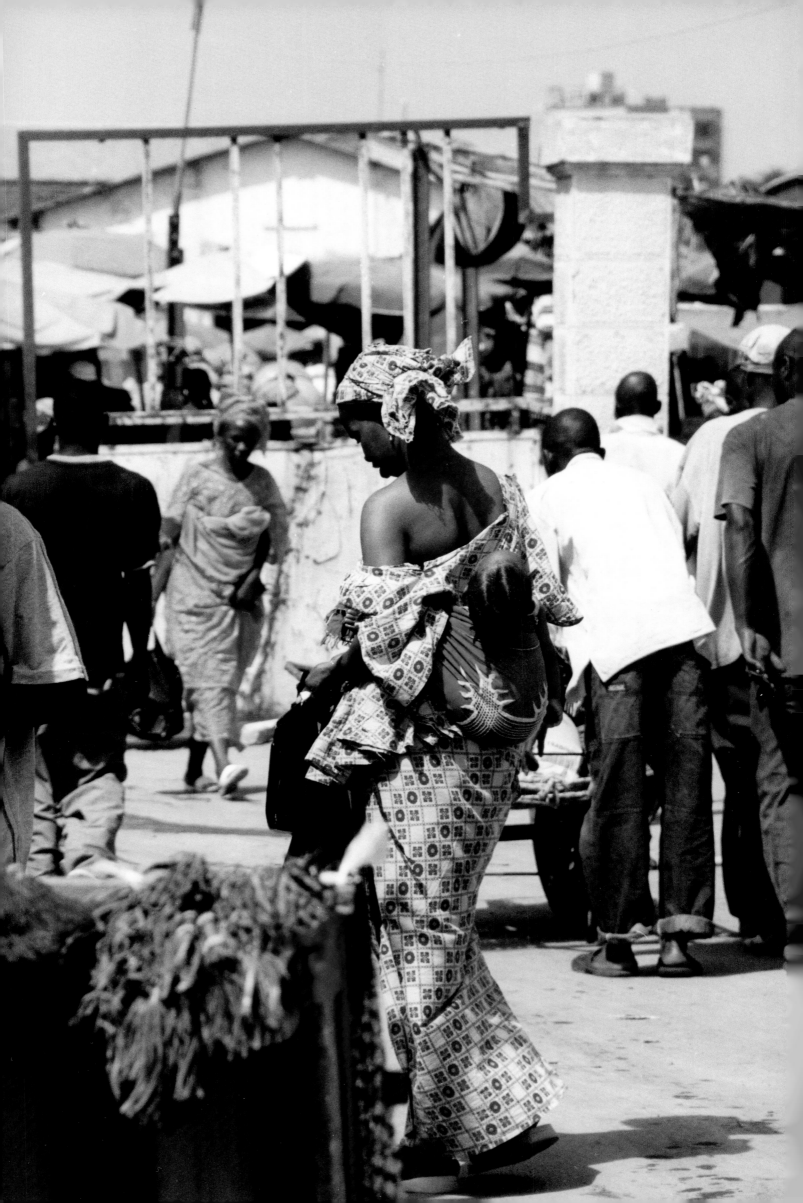

Afternoons, the girls change into the voluminous navy blue pants and smocks provided by Aminata and disperse to shops around town where their mentors teach them to change oil and replace clutches and cut two-by-fours on a table saw. At an auto-repair shop, two of Aminata's students peer under the hood of a 1987 Renault as the head mechanic explains how to change sparkplugs, using a 1980s Toyota owner's manual as a de facto textbook. "When we first started, the male mechanics thought it was a joke, a bunch of women who wanted to fix cars," says Ndey Haddy, a stocky fifteen-year-old who bounces a basketball between her legs as we talk. "They treated us as their assistants: 'Go get me this tool, go get me that tool,' they were always saying. But now that we've worked with them for a few weeks, they take us more seriously."

When we first started, the male mechanics thought it was a joke...

Aminata also conducts workshops on women's rights that touch on domestic violence, sexual harassment, labor rights, and reproductive health. "I want these girls to be aware that they deserve to be treated with respect by their partners and their employers, and to have the confidence and courage to stand up for themselves if there is a problem," she says. Among the points she stresses is the importance of earning their own money, so they don't have to depend on anyone. She speaks from experience: Aminata is divorced and supports herself and her daughter, who goes to university in France.

On an early evening in November, Aminata summons the fifteen program participants to a community center in Khar Yalla for a workshop. They gather in the courtyard, babies perched on their hips or tethered to their backs with a swatch of fabric. The courtyard is steeped in the amber light of a waning sun. From the middle distance comes a muezzin's sinuous call to prayer.

Aminata stands before them in a lavendar headwrap and a swirling ankle-length silk dress, a commanding and radiant presence. She speaks with the authority of someone who has addressed large audiences of dignitaries. Holding up a laminated illustration of a woman beside a man bearing a large wooden stick, she asks, "What do you see in this picture?"

"A man who is violent with his wife," the girls murmur shyly, echoing each other.

"Why is it wrong for a man to beat his wife?" she asks.

OPPOSITE
A street scene in Dakar.
THIS PAGE
A man selling fabric.

153

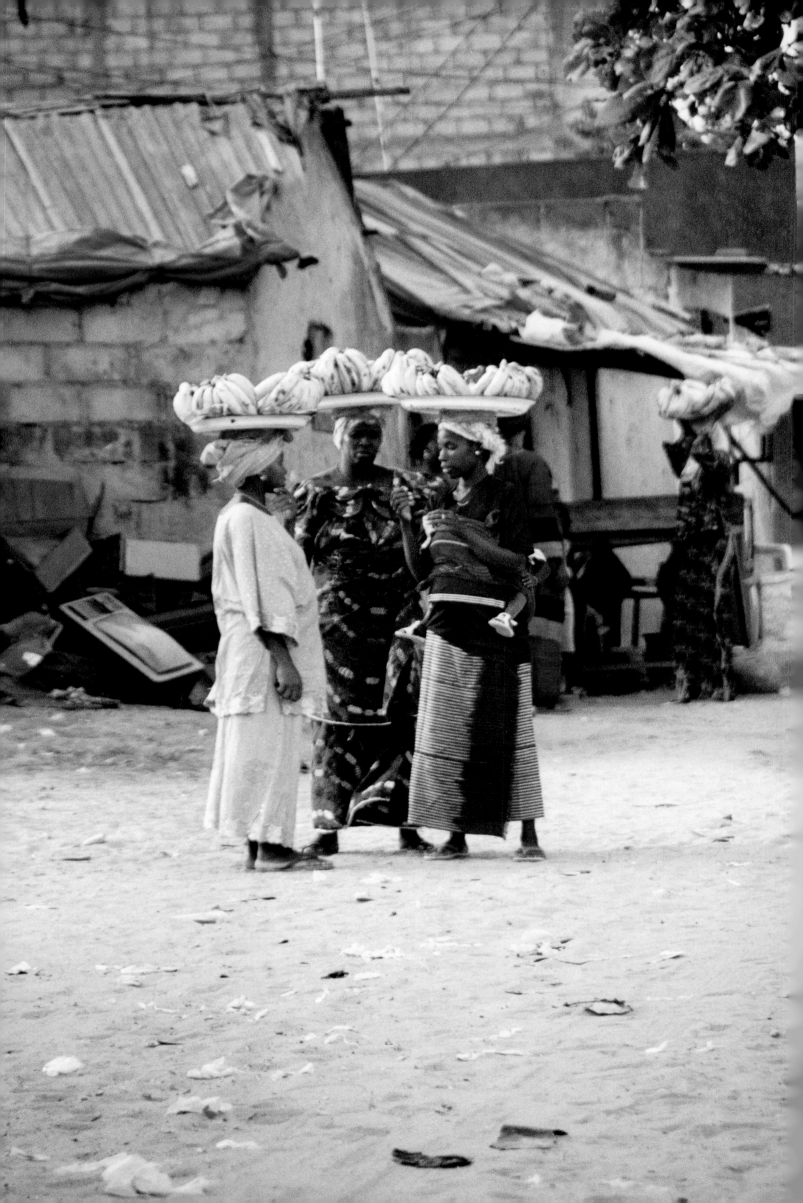

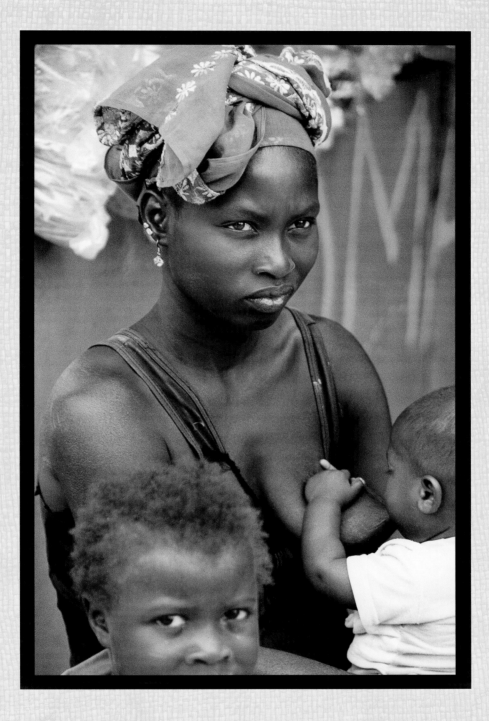

OPPOSITE
A market in Dakar.
THIS PAGE
A woman nursing her baby in Dakar.

THIS PAGE **Festival time in Khar Yalla.**
OPPOSITE **Preparing food in Khar Yalla.**

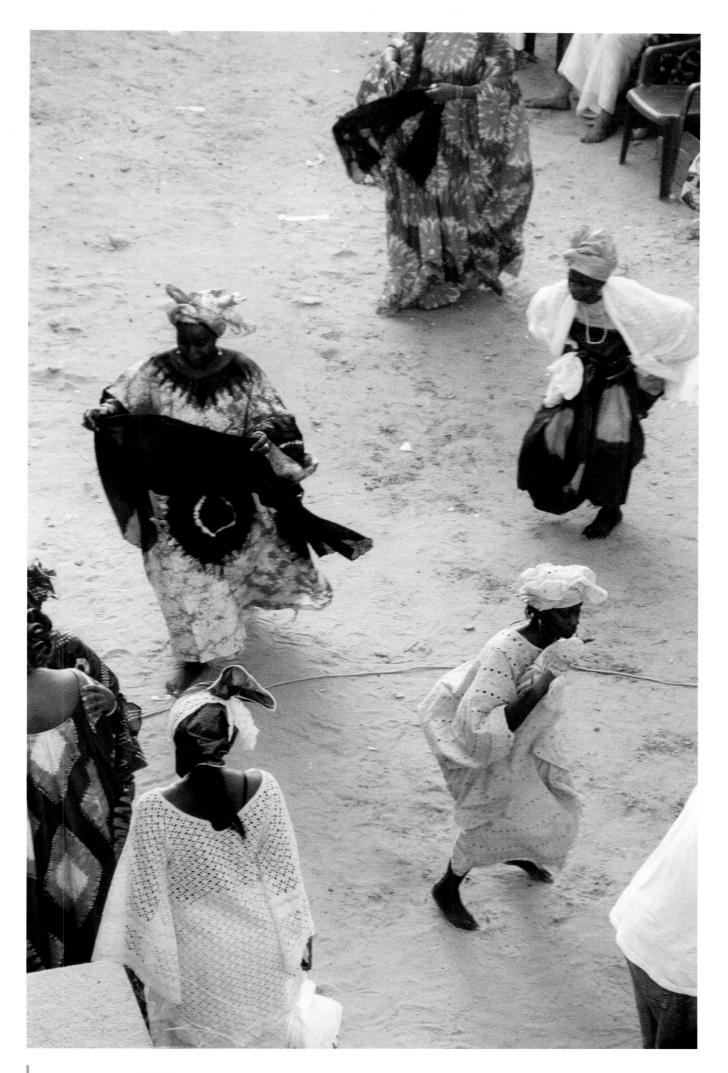

OPPOSITE **A woman in Dakar.**
THIS PAGE **Women dancing in Khar Yalla.**

"It's inhuman," says a girl with short, ruffled hair and Egyptian eyes. "It teaches violence to their children," says another. "Men are the head of the household, so they should be leading their wives and children down the right path," a girl in a crimson headscarf says, a slight edge to her voice.

"Why is that the man's role?" Aminata asks.

"Because women don't know better," the girl says. "They get angry over flimsy things." Aminata widens her eyes. "Is this true?" she asks. She is trying not to sound incredulous. Some girls shake their heads emphatically; others nod and giggle.

Over the next half hour, Aminata presents a dozen more illustrations—pictures of girls going to school alongside older women, of pregnant women washing clothes, of a woman in line at a bank—and the girls give their feedback. The last illustration is of a woman fixing a car.

"What do you see here?"

life is changing, and we have to adapt

"A job that used to be off-limits to me," says the short-haired girl. "Women can have the same strength that men have to make machines work," the woman next to her calls out. Then the girl in the crimson headscarf timidly offers her perspective: "Before, people thought that women's lives were limited to the household," she says. "But life is changing, and we have to adapt."

Aminata beams.

The girls will apprentice with an expert in their field for eighteen months. When their training is concluded, some girls will open their own businesses; others will have the option of staying on at the shop where they apprenticed. If a girl's boss cannot offer his apprentice a position at his shop, he will at least help connect her to other shop owners. Anta's boss estimates that a metalworker can earn between $1000 and $3000 a month if she runs her own business— 300 times what women earn doing petty commerce on the side of the road or braiding hair, which only pays about $15–$60 a month. Aminata also plans to start a professional association for women in the male trades to provide emotional and logistical support, and to help them apply for microcredit loans.

Even with all the assistance provided by La Case des Jeunes Femmes, all the workshops and support and guidance, the girls struggle with the discouragement and ridicule of their friends and relatives. "Many people tell me that this job is inappropriate for a girl like me, or that a woman will never advance in this industry," says Anta. But she is undeterred. She has plans: she wants to send her son to school, buy a house. "This job is my ticket to a secure future," she says. "I'm determined to be successful. I'm going to prove all my critics wrong."

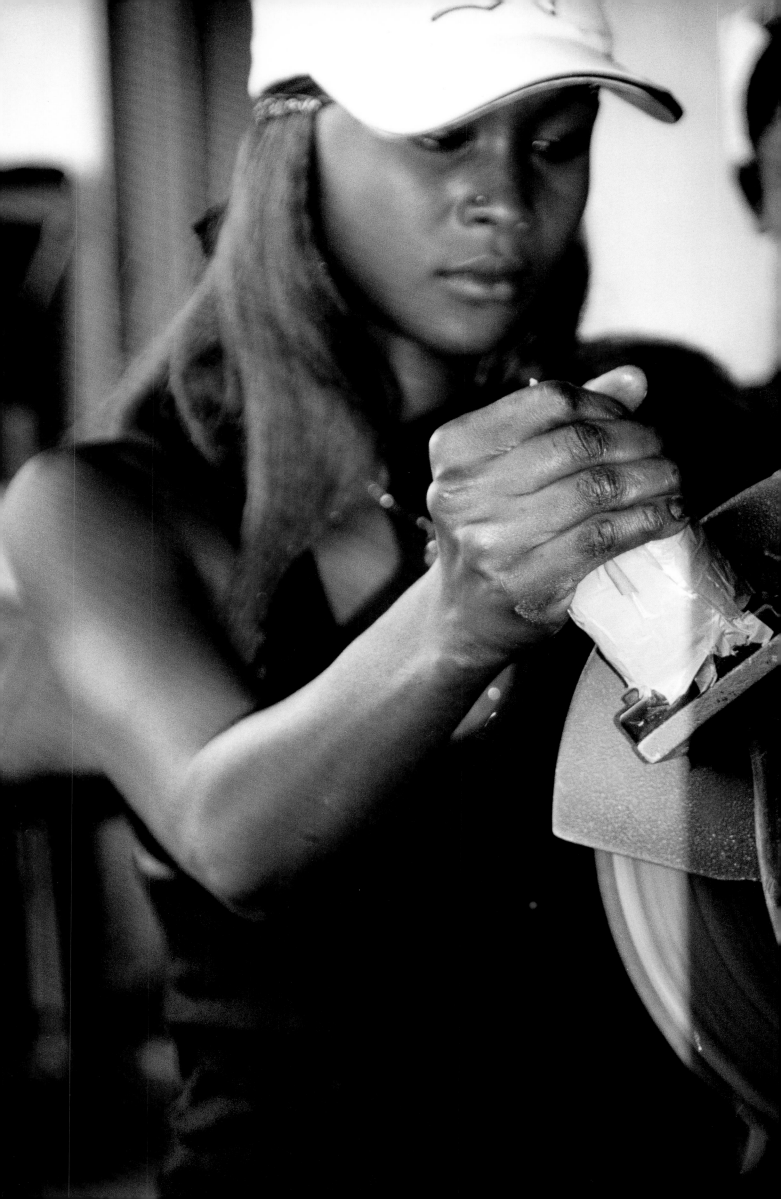

HISTORY OF REGION:

Mali is a landlocked nation, 65% of which is desert land. It can be separated into three natural zones: southern, cultivated Sudanese savanna around the Niger River; central, semiarid Sahelian; and northern, sand-covered Saharan plains.

In ancient times the area was home to the three great empires of Ghana, Mali and Songhai. These kin-based societies controlled the trade of gold, salt, ivory, and other precious commodities along the Niger River. The famed cities of Djenné and Tombouctou thrived as financial and scholarly hubs during this time. In 1591 the Songhai Empire fell under Moroccan invasion, and the advent of ship-based trading by the Portuguese made the trans-Saharan trade route obsolete.

French settlers arrived in the late 1800s, eventually seizing control of the area. The French Sudan, renamed the Sudanese Republic, joined with Senegal in 1959 to form the Mali Federation, which gained independence from France a year later. Senegal withdrew from the union after a few months, and the Republic of Mali was established on September 22, 1960, lead by Modibo Keïta.

CURRENT SITUATION:

Around 80% of Mali's 11,716,829 people subsist on herding, fishing, and farming. Nomadic people make up 10% of the population. A good 90% of Malians are Muslim, and although French is Mali's official language, Bambara is spoken most frequently. Frequent drought, malnutrition, and poor sanitation and hygeine are serious threats.

Mali was ruled by dicatorships until 1991, when a coup lead by Amadou Toumani Touré ushered in its first democratic government, with Alpha Konare elected president. He served for two terms, and in 2002 Amadou Toumani Touré took office. Touré's administration includes representatives from many parties in an effort to promote consensus.

CHILD LABOR
MALI
JACQUELINE GOITA

They arrive in Bamako every day, groups of teenage girls in airless green mini-buses, dressed in fabric wraps and cast-off T-shirts from Western charities. Although they will not return home to their villages for months, maybe years, they carry almost nothing. A small bundle of clothes. A few damp franc notes. Some of them have the address of an "uncle," probably not a blood relative, but a man from their village who has made it in the big city and who is obligated by culture and tradition to take in young, jobless villagers until they get on their feet.

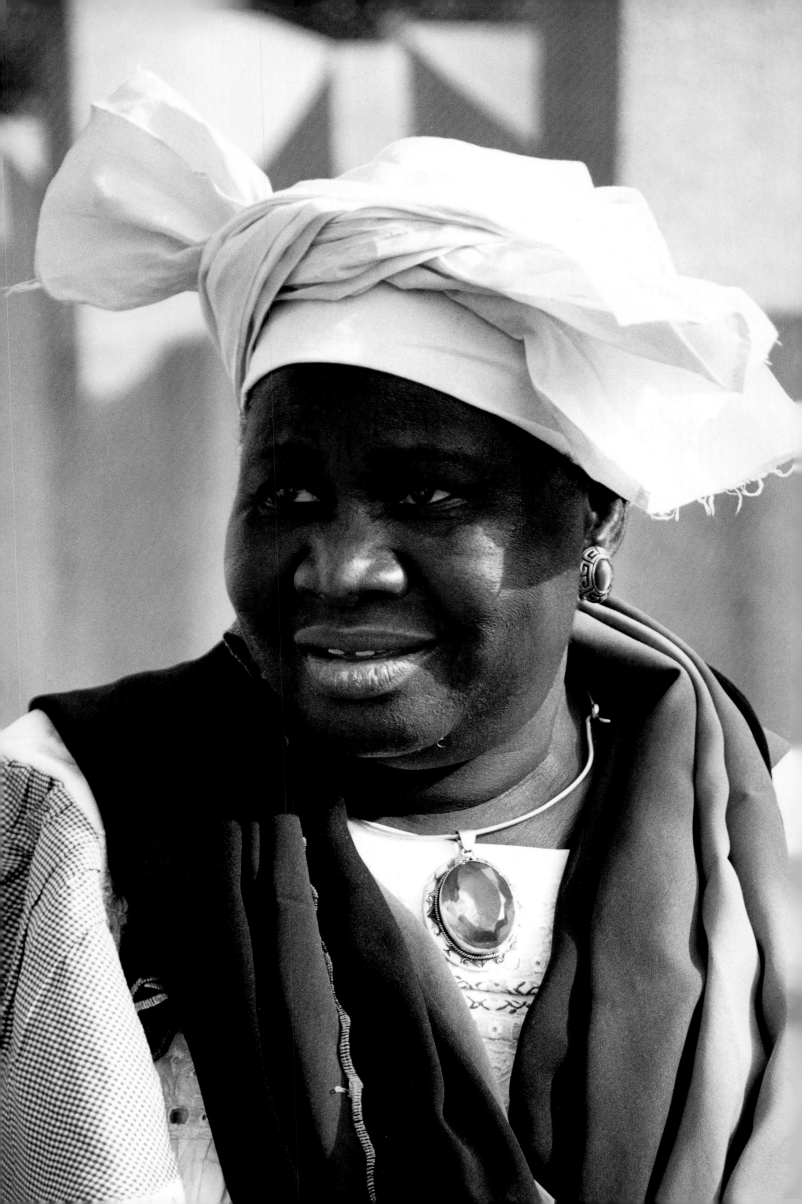

The girls come looking for work and hoping to bankroll their wedding trousseaus. They are in the first flush of adolescence, and they are expected to marry before they are twenty or twenty-one. There are not many employment options for an illiterate, unskilled village girl, so most of them fall into the one job that is open to them: they become maids. The salaries, meager as they are, pay more than they could ever dream of earning back home.

OPPOSITE
Jacqueline Goita.
THIS PAGE
TOP Koro Camara in her village.
BOTTOM A rural village in Mali.
OVERLEAF
A Bamako Street.

Koro Camara was fifteen when she arrived in Bamako to search for a job as a domestic worker. Her father, a subsistence farmer, has two wives and ten children. Purchasing the dishes and kitchenware that new brides are expected to bring into their marriages is way beyond his means, as it is for most villagers. Within two days, Koro, a softspoken girl with a cherubic face, had a job cleaning, cooking, and taking care of a five-month-old baby for a soldier and his wife. In exchange for working from 5:30 AM until bedtime with no days off, she is paid twelve dollars a month. In Bamako, even the poor have maids, and the family that Koro works for hovers just above the poverty line. They live in a two-room house with a tiny courtyard crisscrossed by laundry lines hung with khaki military uniforms. Like most maids who work for impoverished families, Koro sleeps on the dirt floor of the storehouse, where the rice and meal is kept—there are no spare rooms.

Because village girls like Koro are invariably illiterate and naïve in the ways of the city, they are ripe for exploitation. Many are underpaid and overworked by their employers, and physically or sexually abused. Realizing how vulnerable these girls were, Jacqueline Goita launched an organization in 1987 to help improve conditions for these young domestic workers. This organization called, in English, Toward the Promotion of Familial Protection (APAF), is part watchdog organization, part training program, and part job-placement agency. Every girl who registers with APAF is assigned a caseworker who monitors how she is being treated—to ensure that she is being fed, lodged, and paid adequately, and that she is not being abused. If a girl lodges a complaint against her employer, or vice versa, a caseworker meets with both parties to discuss the situation. APAF collects and distributes the girls' paychecks as a way of ensuring that the girls are getting paid regularly and on time, and the staff also works to prevent domestic workers from being trafficked to other countries where they may end up as either unpaid servants or sex workers.

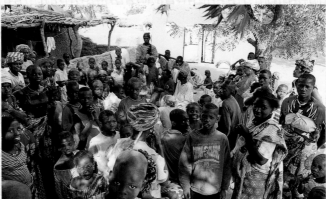

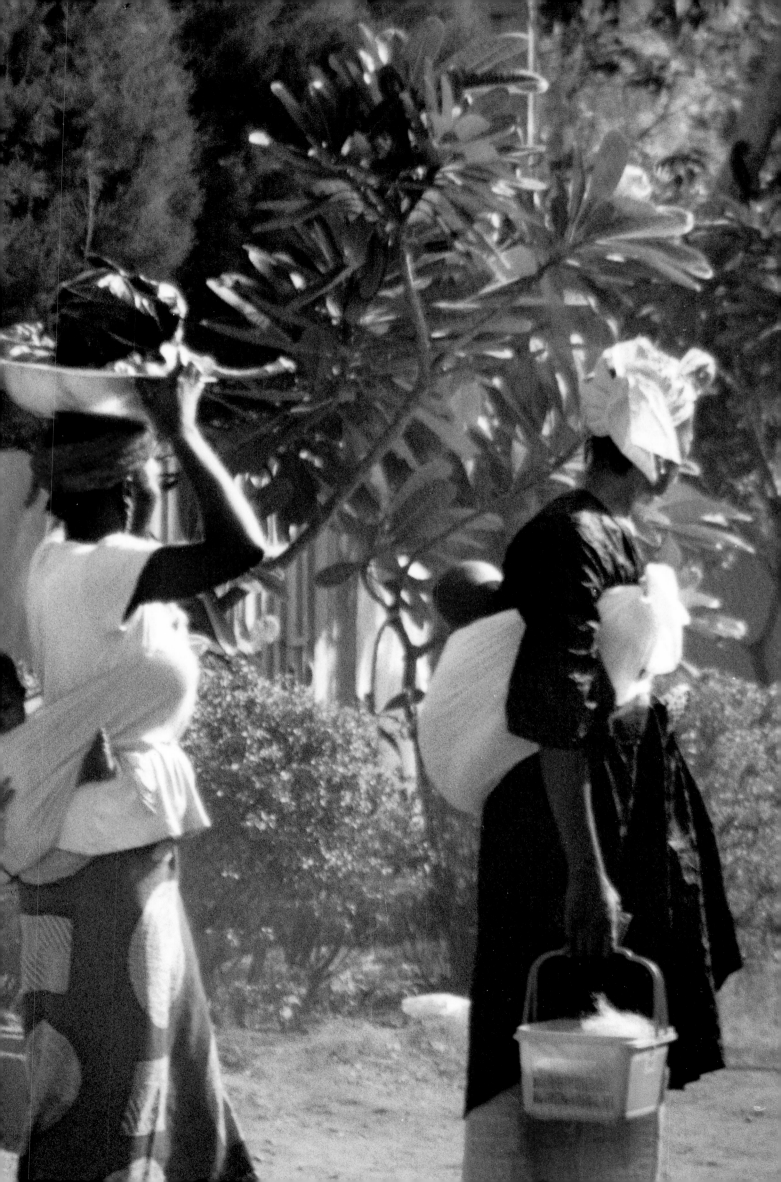

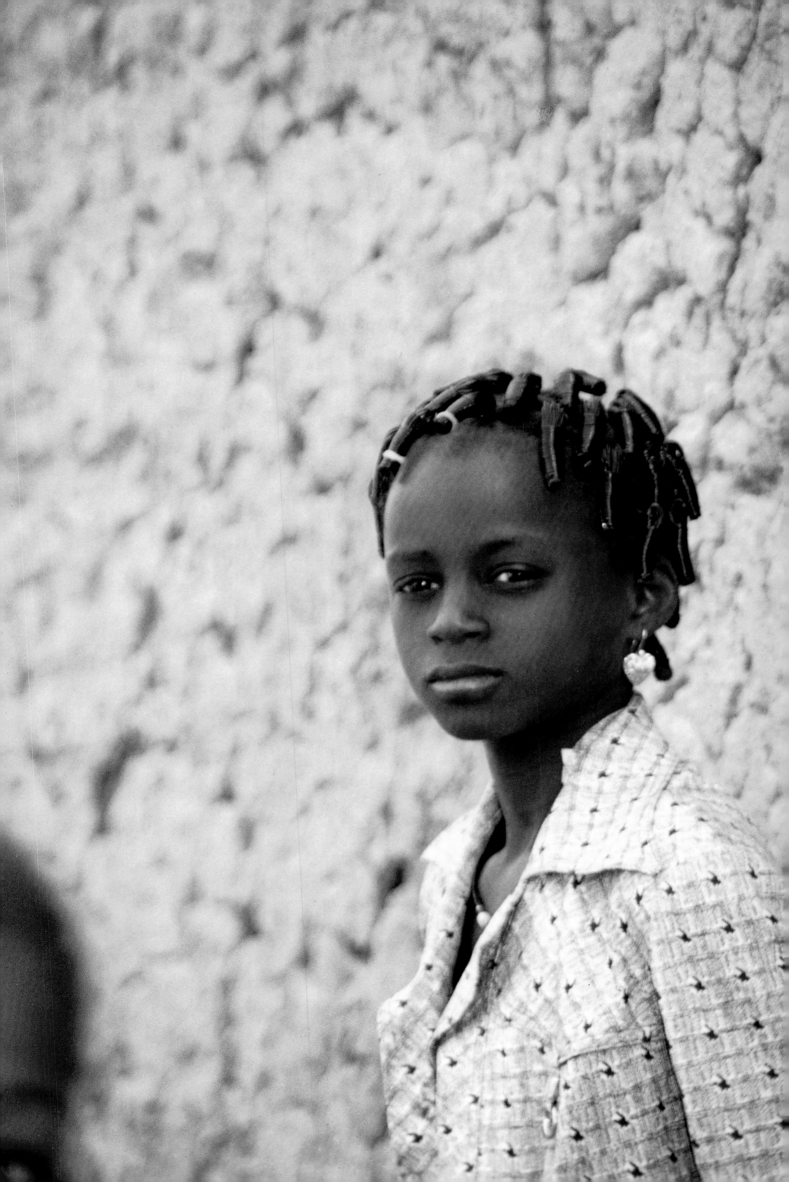

These girls arrive in the city unable to even read a sign. Imagine how vulnerable that makes them.

Jacqueline is sixty-two years old, an ample woman dressed in gingham and ruffles with a voice that carries and a habit of punching the air for emphasis. From a metal file cabinet, she pulls a stack of frail ledger books labeled in bright blue marker. "Cases of rape," "cases of violence," "cases of AIDS," they read. Inside are photographs of the victims—all domestic workers— and descriptions of the crimes committed against them. There is a case of a girl who was gang-raped and left for dead. Another of a girl who was raped by her employer and later died of a botched secret abortion. When a case like this is reported to Jacqueline, she hires a lawyer to bring the case to court. Although justice is often elusive—the courts are notoriously corrupt—the mere act of making the crime public is an improvement. It offers the poor and exploited a voice where previously they had none.

Because these girls were raised in mud huts cooking over open fires, most of them have never seen the modern kitchens that confront them when they arrive for their first day of work in Bamako. They have never cooked over a burner, scrubbed a tile floor, or stored food in cabinets or a refrigerator. To bring the girls into the twenty-first century, or at least the twentieth, Jacqueline launched a training program to teach them these skills and more. The program, which is free to any girl interested in enrolling, aims to transform the girls into highly qualified maids, which translates directly into higher salaries. Graduates of APAF's program generally earn about forty-five dollars a month, while girls who have not undergone training only earn about nine dollars. Once a girl finishes the training, APAF places her in a job and monitors her progress.

The girls also attend literacy classes where they are taught to write in Bamaran, the local dialect of Bamako. "These girls arrive in the city unable to even read a sign," says Jacqueline. "Imagine how vulnerable that makes them. They are completely disempowered." In the ledger book where the girls confirm that they have received their paychecks, they leave indigo thumbprints in lieu of their printed names.

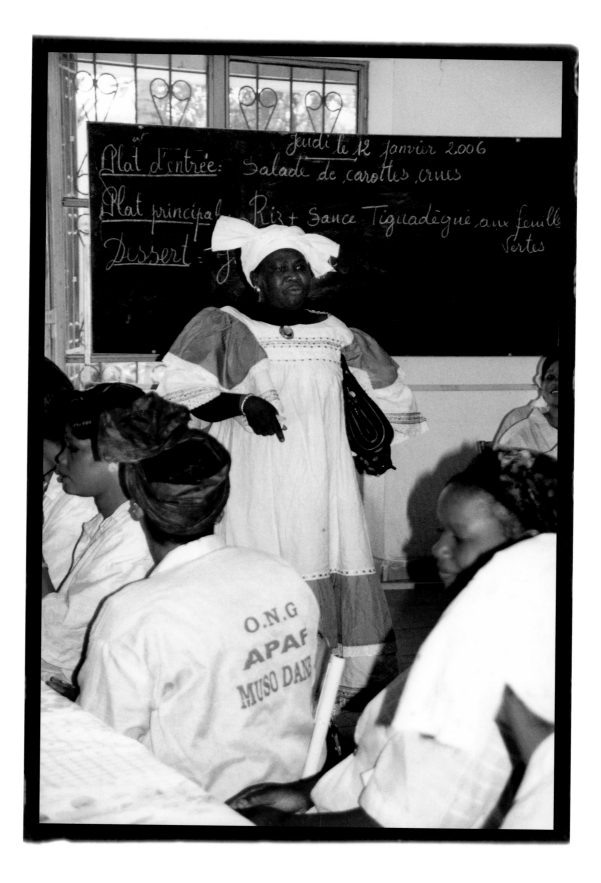

On the blackboard:

Jeudi le 12 Janvier 2006
Plat d'entrée: Salade de carottes crues
Plat principal: Riz + Sance Tiguadègue aux feuilles vertes
Dessert:

OPPOSITE
TOP Grinding herbs with a mortar and pestle.
BOTTOM Listening to a lecture on reproductive health.
THIS PAGE
Madame Jacqueline introduces a cooking class.

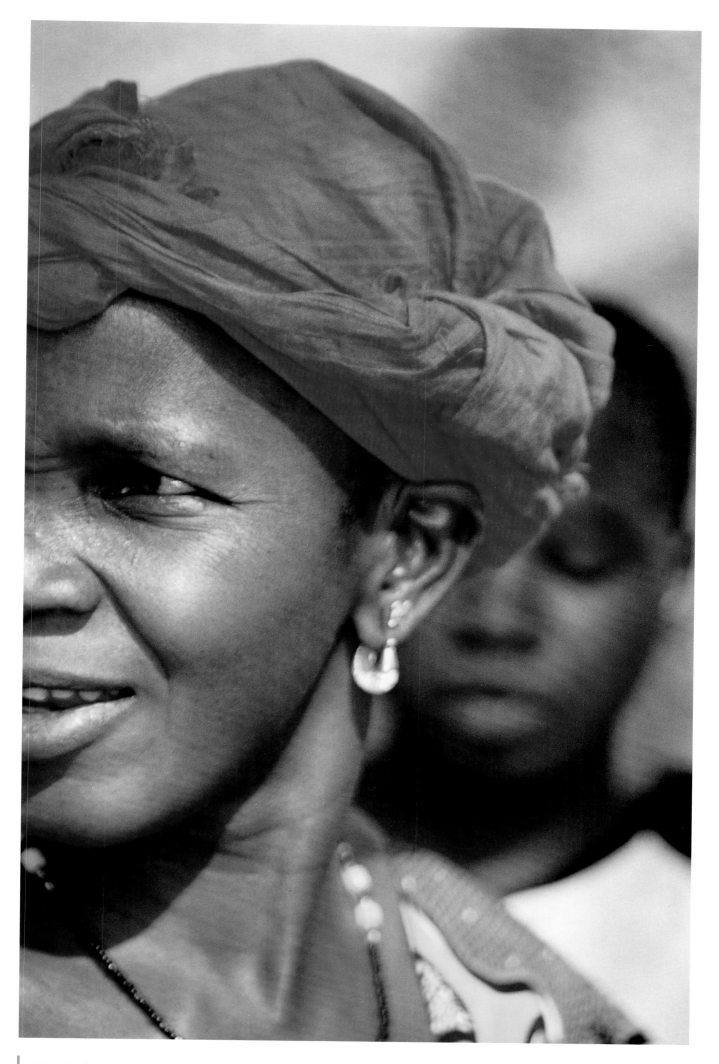

OPPOSITE **A woman in Bamako.**
THIS PAGE **A village woman with Koro.**

Dressed in Pepto-Bismol pink smocks, fifty girls and a smattering of boys gather every day in the linoleum-tiled conference room of a government building. They learn both practical and theoretical lessons that will help them as they take on new jobs and navigate the confusing urban landscape. They might learn how to wash vegetables properly in the morning and how to use condoms correctly in the afternoon. On the day we visit, the class is divided in two. Half of the students watch as one of the male students demonstrates how to put a condom on a polished wooden penis, while he barely conceals a smirk. Meanwhile, in the courtyard, a professor of home economics is teaching the other half of the class to prepare chicken stew. The courtyard is a labyrinth of plastic tubs filled with greens and tomatoes soaking in chlorinated water to kill the bacteria. Back home, most girls learned how to cook only the few staple foods villagers could access. Helping students expand their cooking repertoire is an important factor in preparing them for higher-paying jobs. In the world of domestic workers, the ability to make spaghetti is considered a great asset. "The wealthier employers will often request Western dishes," says Jacqueline. "They specifically ask for girls who have these skills when they approach us about hiring a girl."

Working as a domestic servant is one of the least desirable ways to earn a living in Mali, and Jacqueline doesn't romanticize it. In an ideal world, she would prefer to see village girls get an education and start small businesses in their own villages, close to family and tradition and far from the temptations and dangers of the city. To that effect, Jacqueline has teamed up with two non-governmental organizations to urge parents to send their children to school in rural areas and to provide vocational training so they can start their own small businesses braiding hair or selling provisions. But Jacqueline is a realist. She knows that many village girls will never be given the opportunity to go to school, that jobs for the educated are scarce, and that girls will continue to flock to Bamako every year to work as maids. And as long as that keeps happening, Jacqueline is committed to ensuring that these girls are safe and that they are treated with dignity.

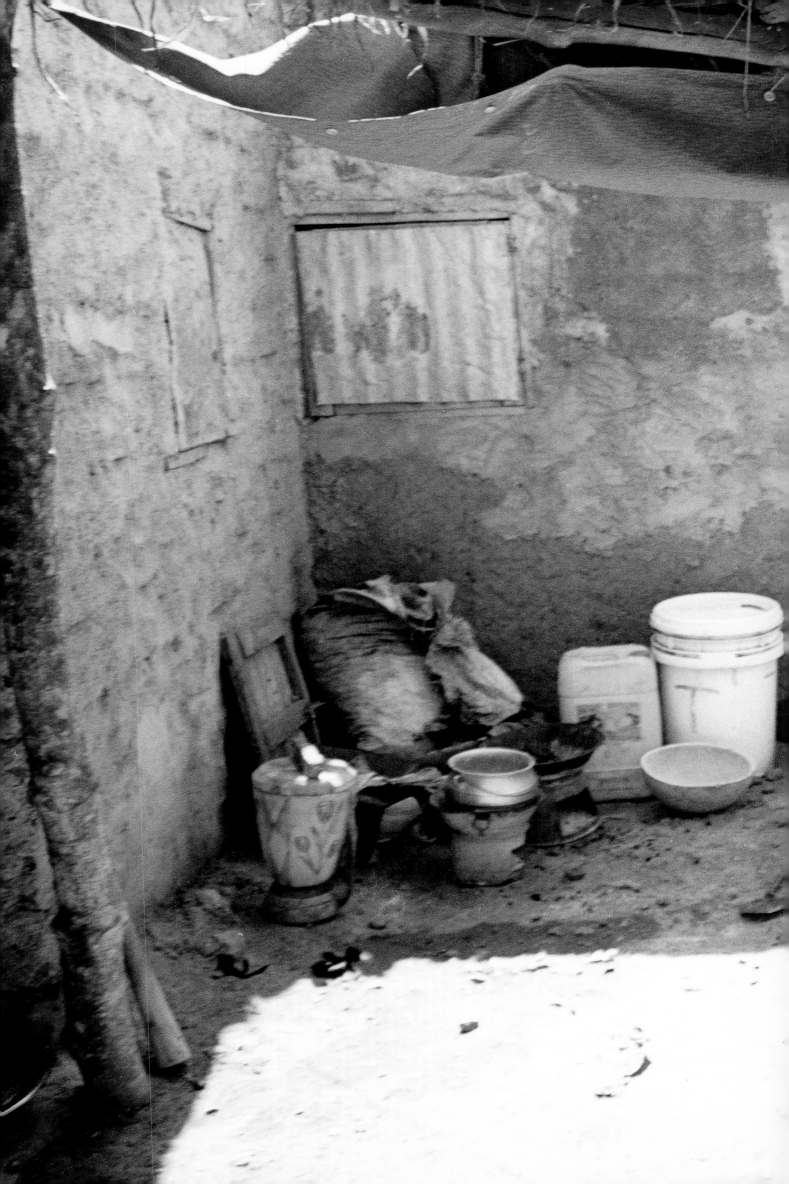

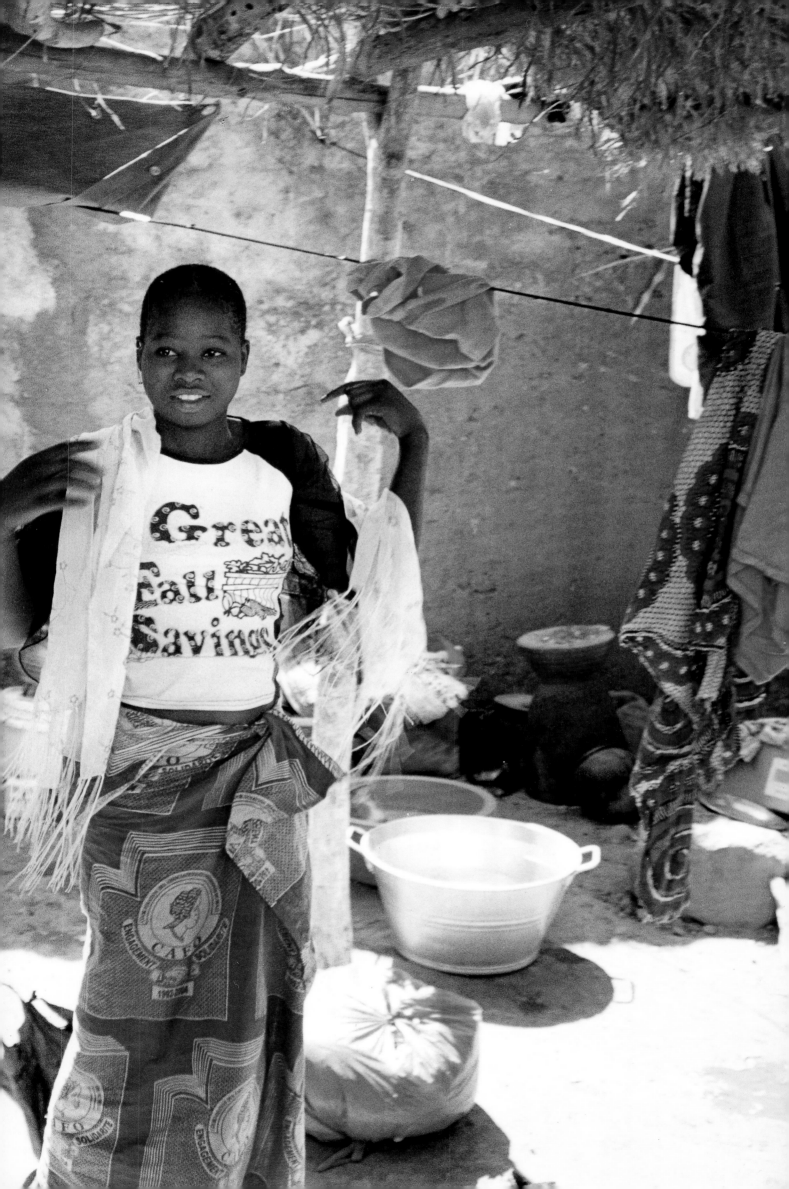

Jacqueline, known as "Madame Urban" by her rural charges who regard her as their tutor in the mysterious ways of the city, has never been content with following the status quo. As a child, she was the only girl in her village to attend school. As a mother, she was one of a tiny group of women who refused to subject her daughters to female genital mutilation, a painful and dangerous traditional practice which involves excising an adolescent girl's clitoris to negate her sexual pleasure. "It was an absolute secret," she says of her choice. "The few of us who made that decision didn't dare let anyone know; we would have been considered heretics."

Taking on the exploitation of poor rural girls arose from Jacqueline's sense that what Malian society accepted as normal was not right, and that she could change that. "These girls are the most neglected members of our culture, and it is easy for most people to overlook their rights," she says. "But I am not content to just say that life is unfair. Every person should have a chance to improve their circumstances. No one should have to accept being mistreated."

Every person should have a chance to improve their circumstances. No one should have to accept being mistreated

Because they are poor and uneducated, and because they tend to internalize their positions of servitude, these girls do not feel entitled to complain if they are mistreated in their jobs. To complain is to risk being fired. Understanding their mentality, Jacqueline has a case worker bring each girl home to her village for a visit after her first three months of work. It is a way for the girl to reconnect with her family, of course, but it also provides an opportunity for her to talk openly, far from the scrutiny of her employer.

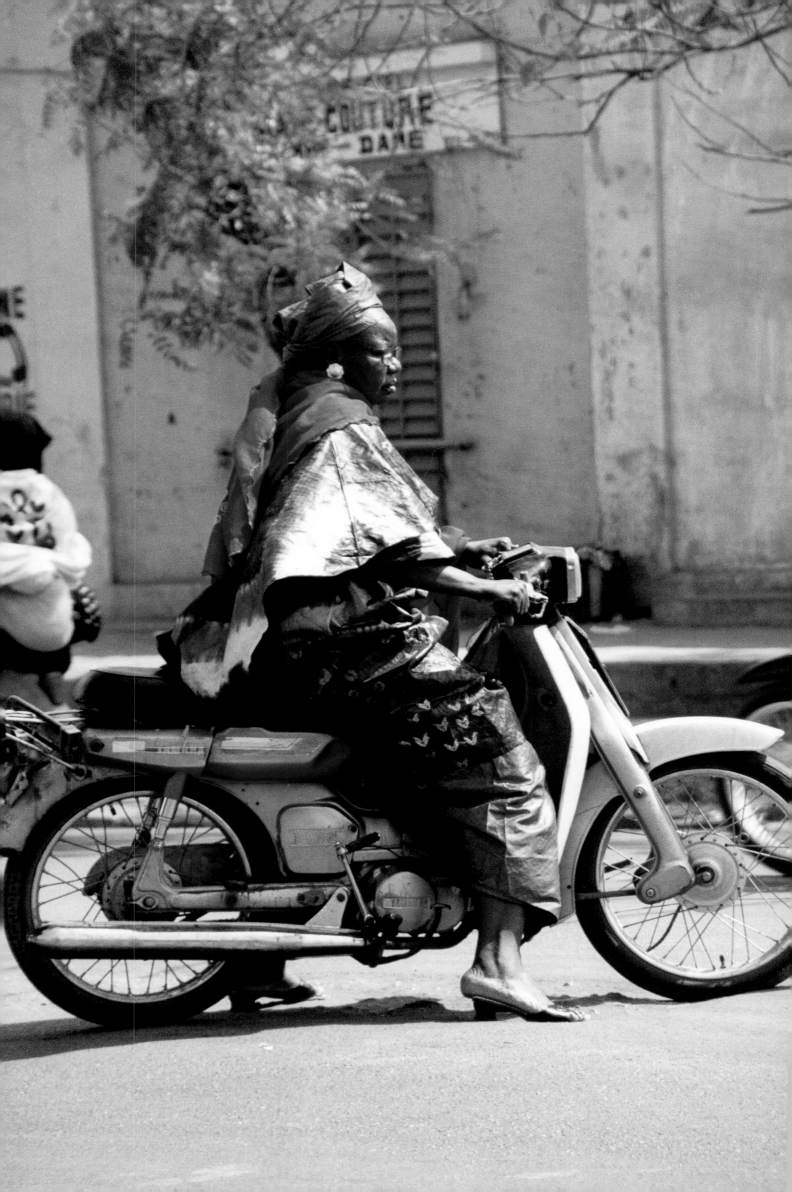

Koro has not been home once since she arrived in Bamako, so her caseworker, a tall, majestic woman named Madame Keita, arranges for a visit while we are there. During the three-hour drive, Koro confides in Madame Keita that her employer's wife withholds food from her when she is unhappy with Koro's work. She also tells Madame Keita that she would like to enroll in APAF's training program so she can get a better job. But she needs the blessings of her parents and the village elders first. Because her mother specifically instructed her to get a job as quickly as possible, Koro is worried that she will be refused this opportunity. Madame Keita promises to do her best to convince them that the training program will provide long-term benefits.

Koro begins to weep as soon as she sees her father leaning against a sparsely stocked provision store at the outskirts of her village. He greets her stoically, as does her mother. Koro is Dogon, and affection is not customary among her people. Koro's caseworker explains the purpose of her visit, and we are summoned to the village center to meet the village elders. We sit on stools made from tree stumps, surrounded by the mud huts whose windows have been stuffed with pillows to block the midday sun. Koro lingers shyly on the periphery of the circle, looking slightly uncomfortable. She is a city girl now, sophisticated and intimidating to the other children of the village who are dusty and barefoot. They shamelessly ogle the champagne-colored Land Rover, with its three DVD screens, that Koro arrived in, like some sort of princess in a chariot.

Madame Keita explains the benefits of APAF's training program to a semicircle of elderly men who grunt "mm-hmm" in unison every few sentences. Then she asks the village spokesperson, a somber man with an impassive, granite face, if Koro's male relatives and elders will grant Koro permission to participate in the program. The man turns to Koro's father to explain the request. The men debate the proposal for a few minutes in their local dialect, the spokesperson running a calloused finger thoughtfully across his upper lip. Then the spokesman reports back in Bamaran: they will grant Koro permission, with the stipulation that her "uncle," the man who first took her in when she arrived in Bamako, allow her to stay with him while she goes through the program. Hearing the news, Koro suppresses a tiny smile, but says nothing.

Before returning to Bamako, Koro's mother hands her a garbage bag full of peanuts, which were grown on the family's farm. Koro puts it in the back of the Land Rover, then climbs on top of it, the eyes of the children following her hungrily. She cries silently as her father bids her goodbye through the car window. Madame Keita tries to reassure her, saying that she will speak with Koro's uncle the next day, and that within a few months, she will most likely have a better job. Within a half an hour, Koro has drifted off to sleep, her head against the window, her expression peaceful.

THIS PAGE **A village child.**
OPPOSITE **A woman at work in Bamako.**

SELECT BIBLIOGRAPHY

KENYA

Anderson, David. *Histories of the Hanged: The Dirty War in Kenya and the End of Empire.*
New York: W. W. Norton & Company, 2005.

Booth, Karen M. *Local Women, Global Science: Fighting AIDS in Kenya.*
Bloomington: Indiana University Press, 2003.

Halperin, Helena. *I Laugh So I Won't Cry: Kenya's Women Tell the Story of Their Lives.*
Trenton, New Jersey: Africa World Press, 2005.

Haugerud, Angelique. *The Culture of Politics in Modern Kenya.* Cambridge: Cambridge University Press, 1997.

Maathai, Wangari. *The Greenbelt Movement: Sharing the Approach and the Experience.*
New York: Lantern Books, 2003.

Mwaura, Ndirangu. *Kenya Today: Breaking The Yoke of Colonialism in Africa.* New York: Algora Publishing, 2005.

Thomas, Lynn M. *Politics of the Womb: Women, Reproduction, and the State in Kenya.*
Berkeley: University of California Press, 2003.

Wong, Lana. *Shootback: Photos by Kids from the Nairobi Slums.* London: Booth-Clibborn, 2000.

MALI

Bingen, James R., David Robinson, and John M. Staatz, editors. *Democracy and Development in Mali.*
East Lansing: Michigan State University Press, 2000.

Huynh, Jean-Baptiste. *Mali.* Milan: 5 Continents Editions, 2004.

Joris, Lieve. *Mali Blues: Traveling to an African Beat.* London and Paris: Lonely Planet Publications, 1998.

Lucke, Lewis. *Waiting for Rain: Life and Development in Mali, West Africa.*
Hanover, Massachussetts: Christopher Publishing House, 1998.

MOZAMBIQUE

Andrade, Ximena and Terezinha Da Silva. *Beyond Inequalities: Women in Mozambique.*
Harare, Zimbabwe: Southern African Research and Documentation Centre, 2000.

Finnegan, William. *A Complicated War: The Harrowing of Mozambique.*
Berkeley: University of California Press, 1992.

Pitcher, Anne M. *Transforming Mozambique: The Politics of Privatization, 1975–2000.*
Cambridge: Cambridge University Press, 2002.

Sheldon, Kathleen E. *Pounders of Grain: A History of Women, Work, and Politics in Mozambique.*
Portsmouth, New Hampshire: Heinemann, 2002.

Urdang, Stephanie. *And Still They Dance: Women, War, and the Struggle for Change in Mozambique.*
New York: Monthly Review Press, 1989.

RWANDA

Berry, John A., and Carol Pott, editors. *Genocide in Rwanda: A Collective Memory.*
Washington, DC: Howard University Press, 1999.

Dallaire, Roméo. *Shake Hands with the Devil: The Failure of Humanity in Rwanda.*
Toronto: Random House Canada, 2003.

Gourevitch, Philip. *We wish to inform you that tomorrow we will be killed with our families: Stories from Rwanda.*
New York: Farrar, Straus and Giroux, Picador USA, 1998.

Hatzfeld, Jean. *Machete Season: The Killers in Rwanda Speak.* Translated by Linda Coverdale.
New York: Farrar, Straus and Giroux, 2005.

Keane, Fergal. *Season of Blood: A Rwandan Journey.* New York: Penguin, 1997.

Melvern, Linda. *Conspiracy to Murder: The Rwanda Genocide and the International Community.*
London: Verso, 2004.

SENEGAL

Gusewell, C. W. *Africa Notebook.* Kansas City: Lowell Press, 1986.

Renaud, Michelle L. *Women at the Crossroads: A Prostitute Community's Response to AIDS in Urban Senegal.*
London: Taylor & Francis, 1997.

SOUTH AFRICA

Butler, Anthony. *Contemporary South Africa*. New York: Palgrave Macmillan, 2003.

Kauffman, Kyle Dean, David L. Lindauer, and Desmond Tutu. AIDS *and South Africa: The Social Expression of a Pandemic*. New York: Palgrave Macmillan, 2004.

Krog, Antjie. *Country of My Skull: Guilt, Sorrow, and the Limits of Forgiveness in the New South Africa*. New York: Three Rivers Press, 2000.

Sparks, Allister. *Beyond the Miracle: Inside the New South Africa*. Chicago: University of Chicago Press, 2004.

Thompson, Leonard. A *History of South Africa*, 3rd ed. New Haven: Yale University Press, 2001.

Waldmeir, Patti. *Anatomy of a Miracle: The End of Apartheid and the Birth of the New South Africa*. New York: W. W. Norton & Company, 1997.

Worden, Nigel. *The Making of Modern South Africa: Conquest, Segregation and Apartheid*. Oxford: Blackwell Publishers, 2000.

TANZANIA

Bass, Stephen, editor. *Reducing Poverty and Sustaining the Environment: The Politics of Local Engagement*. London: Earthscan Publications, 2005.

Bond, Johanna. *Voices of African Women: Women's Rights in Ghana, Uganda, and Tanzania*. Durham, North Carolina: Carolina Academic Press, 2005.

Conte, Christopher. *Highland Sanctuary: Environmental History in Tanzania's Usambara Mountains*. Athens, Ohio: Ohio University Press, 2004.

Maddox, Gregory, James L. Giblin, and Isaria N. Kimambo, editors. *Custodians of the Land: Ecology & Culture In History of Tanzania*. Athens, Ohio: Ohio University Press, 1996.

Neumann, Roderick P. *Imposing Wilderness: Struggles over Livelihood and Nature Preservation in Africa*. Berkeley: University of California Press, 2001.

Newmark, W. D. *Conserving Biodiversity in East African Forests: A Study of the Eastern Arc Mountains*. New York: Springer-Verlag, 2002.

Woodcock, Kerry A. *Changing Roles in Natural Forest Management: Stakeholders' Roles in the Eastern Arc Mountains, Tanzania*. Aldershot, Hampshire: Ashgate Publishing, 2002.

AIDS

Barnett, Tony, and Alan Whiteside. AIDS *in the Twenty-First Century: Disease and Globalization*. New York: Palgrave Macmillan, 2003.

Connors, Margaret, Paul Farmer, and Janie Simmons. *Women, Poverty and AIDS: Sex, Drugs and Structural Violence*. Monroe, Maine: Common Courage Press, 2005.

D'Adesky, Anne-Christine. *Moving Mountains: The Race to Treat Global AIDS*. London: Verso, 2004.

Guest, Emma. *Children of AIDS: Africa's Orphan Crisis*. London and Sterling, Va.: Pluto Press, 2003.

Hunter, Susan. B*lack Death: AIDS in Africa*. New York: Macmillan, 2003

WOMEN

Berger, Iris, and E. Frances White. *Women in Sub-Saharan Africa: Restoring Women to History*. Bloomington: Indiana University Press, 1999.

Coquery-Vidrovitch, Catherine. *African Women: A Modern History*. Translated by Beth Gillian Raps. Boulder, Colorado: Westview Press, 1997.

Turshen, Meredeth, and Clotilde Twagiramariya, editors. *What Women Do in Wartime: Gender and Conflict in Africa*, vol. 1. London and New York: Zed Books, 1998.

GENERAL HISTORY AND POLITICS

French, Howard. A *Continent for the Taking: The Tragedy and Hope of Africa*. New York: Vintage, 2005.

Guest, Robert. *The Shackled Continent: Power, Corruption, and African Lives*. Washington: Smithsonian Books, 2004

Iliffe, John. *Africans: The History of a Continent*. Cambridge: Cambridge University Press, 1995.

Nugent, Paul. *Africa Since Independence: A Comparative History*. New York: Palgrave Macmillan, 2004.

Pakenham, Thomas. *Scramble for Africa*. New York: Harper Perennial, 1992.

Reader, John. *Africa: A Biography of the Continent*. New York: Vintage, 1999.

DONATIONS Proceeds from the sales of this book will help underwrite the work of these women and others, and you can join us in supporting their vital efforts by also making a contribution to

The Pendulum Project
CONTACT Ellen McCurley, Executive Director
1770 Massachusetts Avenue, Box 625
Cambridge, Massachusetts 02140 USA
TELEPHONE 617-832-0655
FAX 617-832-0656
EMAIL emccurley@pendulumproject.org
WEB www.pendulumproject.org

The Pendulum Project is a registered 501(c)3 humanitarian organization that provides essential resources for community led and managed groups that are working on the frontlines in Africa to alleviate crises including HIV/AIDS, poverty, armed conflict, disease, and hunger. Please take action and support the seven extraordinary women and initiatives featured in this book by making a donation to The Pendulum Project. Or contributions may be made directly to the organizations represented by these seven women:

KENYA (Ann Wanjiru)
CONTACT Esther Mwaura Muiri
GROOTS Kenya Association
P.O. Box 10320-00100
Nairobi, Kenya
TELEPHONE 254/20-2718977; 254/20-3873186
EMAIL grootsk@grootskenya.org

TANZANIA (Edina Yahana)
CONTACT Charles Meshack
Tanzania Forest Conservation Group
P.O. Box 23410
Dar es Salaam, Tanzania
TELEPHONE 255/22-2669007
EMAIL cmeshack@tfcg.or.tz

CONTACT Emily MacDonald, Executive Director
African Rainforest Conservancy
560 Broadway, Suite 202
New York, NY 10012
TELEPHONE 212-431-5508
EMAIL emily@africarainforest.org

MOZAMBIQUE (Celina Cossa)
CONTACT Valeriano Ferrao
Union of General Cooperatives
Praça 25 de Junho No. 1
Maputo, Mozambique
TELEPHONE 258/84-399-8260
EMAIL ferrao@teledata.mz

RWANDA (Pascasie Mukamunigo)
CONTACT Aurea Kayiganwa
Association of Genocide Widows: Avega-Agahozo
P.O. 1535 Kigali, Rwanda
TELEPHONE 250/516-125
EMAIL kayiganwa@yahoo.fr

SOUTH AFRICA (Prudence Mwandla)
CONTACT Sarah Gedye
Khulani Children's Shelter
33 Grove Crescent, Parkhill
Durban North, 4051 South Africa
Or P.O. Box 47274
Greyville 4023 South Africa
TELEPHONE 27/31-5639450
EMAIL sarahg@michelle.co.za

SENEGAL (Aminata Dieyé)
CONTACT Aminata Dieyé
La Case des Jeunes Femmes
B.P. 15437
Dakar Fann, Senegal
TELEPHONE 221/641-40-63
EMAIL casefemme@yahoo.fr

MALI (Jacqueline Goita)
CONTACT Mme. Dembele Jacqueline Goita
Association for Familial Protection
Boîte Postale 8023
Bamako, Mali
TELEPHONE 223/228-17-15; 223/673-24-19
EMAIL apafmusodanbe@afribone.net

ACKNOWLEDGMENTS

This book could only have been done with the advice, love, and support of many people, but first and foremost that of the seven amazing women whose stories are told in this book. They gave of their precious time and energy to help us to help them. Other friends and family are listed below. We thank you all from the bottom of our hearts.

In New York, my trusted friend and amazing literary agent, John Campbell; the wonderful team of Mark Magowan, publisher, and Christopher Sweet, editor, and everyone at The Vendome Press; Jane Johnson, my assistant and angel; Carol Bobolts, designer, and all at Red Herring Design; Carol Fondé, printer extraordinaire; Holly Hunt NYC; Meg Parsont, publicist; Marla Gitterman of the Business Council for Peace; Laura Diaz and Nora Simpson.

My loving family: sons Billy, Ryan, and Christian O'Donnell; my friend, partner, and love, Alex Oviedo. Supporting friends: Patrice Allen, Tina Armstrong, Lindy Reilly, Astrid Lundstrom, Eliza Griswold, Kenlyn Kolleen, Sheila Rooney, Kathy Hunt, Cecilia Rodhe, Christian Rogers, Sandy Findlay, Linda Soloman, Lisa Johnson, Meghan Ingram, Jesse Vare, Cristina Nicoletti, Barbara Eichenlaub, my other "mom" Aunt Harriet, Peter Mattai, Susan Beesemyer, and Sarah Dodd.

In Africa, thanks to our many friends, both new and old, some of whom have been with this project from the beginning, seven years ago. Among them are: Phyllipa and David Marrian, Carolyn Roumeguere, Davina Dobie, Carter Coleman, Priscilla Higham; in Kenya, Esther Mwaura Muiru; in Tanzania, Eustack Bonifasi and Charles Meshack; in Rwanda, Richard Niwenshuti, Gilbert Nyirimanzi, and Aurea Kayiganwa; in Mozambique, Valeriano Ferrao, Joao David Muthombene, Nelson Aires, Custodio Fumo, and Raimundo Sega; in Senegal, Lauren Gelfand, Maestro, and Ebrima Sillah; in South Africa, Sarah Gedye; in Mali, Tidiane Sinaba, Heather Johnston, John Uniack Davis, Sangare Aminata Dicko of CARE, Madame Keita, and to my friend Humphrey Carter who flew me over the Kibera slum.

And thanks to those who helped us find these seven amazing women: Sarah Bouchie of CARE, Liza Barrie and Beatrice Karanja of UNICEF, Alexis Ettinger, Christelle Van Ham, Beverly Schwartz and Leila Akahloun of ASHOKA, Janet Barry and Penelope Riseborough of World Education, Laura Reilly of Opportunity International, Victoria Stanski of Women Waging Peace, Joseph Voeller and Sara Ratika of the Ford Foundation, Lori Michau of Raising Voices, Caroline Driver of Africa Now, Daniel Sarro of Reebok, and Tim Allen of Uganda Children's Charity Foundation.

Designed by Carol Bobolts / Red Herring Design
Maps by David Lindroth
Dossier texts by Erika Tsoukanelis

First published in the United States of America in 2006 by
The Vendome Press
1334 York Avenue, New York, N.Y. 10021

ISBN-10: 0-86565-168-X
ISBN-13: 978-0-86565-168-5

Library of Congress Cataloging-in-Publication Data

O'Donnell, Beth.
 Angels in Africa : profiles of seven extraordinary women / Beth O'Donnell ; text by Kimberley Sevcik.
 p. cm.
 ISBN-13: 978-0-86565-168-5 (alk. paper)
 ISBN-10: 0-86565-168-X (alk. paper)
 1. Women—Africa, Sub-Saharan—Biography. 2. Women—Africa, Sub-Saharan—Pictorial works.
3. Women social reformers—Africa, Sub-Saharan—Biography. 4. Social problems—Africa, Sub-Saharan.
5. Community life—Africa, Sub-Saharan. 6. Women in community development—Africa, Sub-Saharan.
7. Africa, Sub-Saharan—Social conditions--1960- 8. Africa, Sub-Saharan—Social conditions—1960—
Pictorial works. 9. Africa, Sub-Saharan—Biography. I. Sevcik, Kimberley. II. Title.
 HQ1787.5.A3O24 2006
 307.1'4092267—dc22
 [B]
 2006013435

Printed in Singapore

10 9 8 7 6 5 4 3 2 1